for Bili

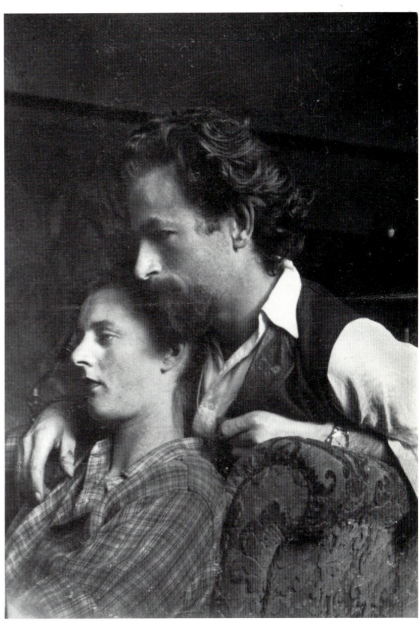

Alan and Bili Davie, January 1948,
taken by the artist's father, James Davie

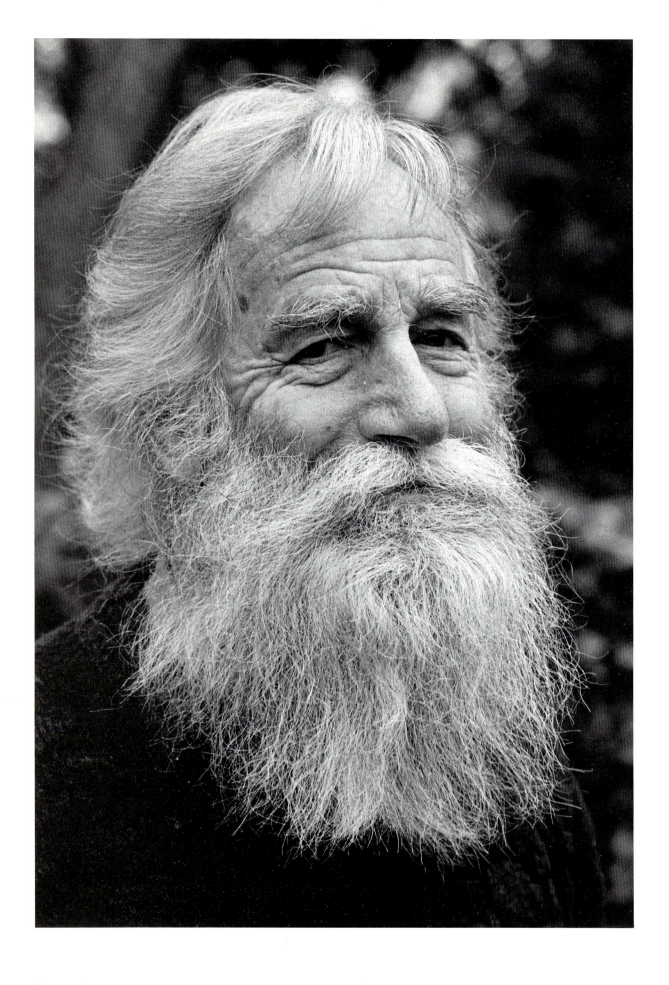

Alan Davie The Quest for the Miraculous

Edited and with an Introduction by Michael Tucker

University of Brighton Gallery in association with
Lund Humphries Publishers
and Barbican Art Gallery

University of Brighton

The Royal Albion Hotel Brighton

Brighton Festival 1993

First published in Great Britain in 1993 by
University of Brighton Gallery
Faculty of Art, Design and Humanities
University of Brighton
in association with
Lund Humphries Publishers
Park House
1 Russell Gardens
London NW11 9NN
and Barbican Art Gallery, London

on the occasion of the exhibitions
ALAN DAVIE: THE QUEST FOR THE MIRACULOUS
University of Brighton Gallery
(Brighton Festival exhibition)
4 to 28 May 1993

subsequently touring to
Hastings Museum and Art Gallery
Ramsgate Gallery
The University Gallery, University of
Northumbria at Newcastle
The University Gallery, Nottingham
The Smith Art Gallery and Museum, Stirling

and ALAN DAVIE
Barbican Art Gallery
8 July to 5 September 1993

British Library Cataloguing-in-Publication Data
A catalogue record for this book is available from
the British Library

ISBN 0 85331 636 8

Designed by Alan Bartram
Made and printed in Great Britain
by BAS Printers Ltd
Over Wallop, Hampshire

Lenders
Arts Council Collection
Alan and Bili Davie
Gimpel Fils
The Trustees of the Tate Gallery, London

Photographic acknowledgements
The frontispiece and cover photographs and
those on pages 72-6 are copyright of Iain Roy.
University of Brighton Gallery and Barbican Art
Gallery would also like to thank the following:
Anthony Critchfield
Rodney Todd-White Photographers
Mike Fearey
Reuben Beckett
Ray Fowler

Cover and frontispiece photographs by Iain Roy

Contents

The black-and-white drawings in
this book have been specially
prepared by Alan Davie for the
publication

Foreword

The University of Brighton Gallery and Barbican Art Gallery are honoured and delighted to have the opportunity to present the work of one of Britain's greatest living artists. Alan Davie is not only a distinctive painter, whose work has long enjoyed an international reputation of the highest calibre; he is also an unusually talented musician, poet and writer, whose reflections upon art, music and poetry are born of the same enthusiasm and sensitivity that nourish and sustain his creative output. As well as documenting the exhibitions at both our galleries, this book celebrates the artist's lifelong commitment to art, his immense *joie de vivre* and creative spirit.

Many people have been instrumental in bringing into being both this book and the University of Brighton Gallery and Barbican Art Gallery exhibitions. First and foremost, our gratitude must go to Alan Davie himself and to his wife Bili, who have supported all aspects of our endeavours with unfailing generosity and good humour. The artist's gallery, Gimpel Fils, London, has been equally helpful; we are most grateful for everything that Gimpel Fils has done in order to ensure the realisation of both the present publication and the exhibitions which it documents.

The University of Brighton show is a Brighton Festival exhibition. We are grateful to Gavin Henderson, Artistic Director of the Brighton Festival, and to Brighton Borough Council and the Royal Albion Hotel, Brighton, for their generous and most welcome sponsorship. We are also grateful to Lianne Jarrett, Press and Publicity Officer for the Brighton Festival, and to the Dean's Advisory Group at the University of Brighton; especially John Crook, Chair of the Group, and Colin Matthews, Exhibition Officer of the University of Brighton Gallery.

The University of Brighton Gallery and the Barbican Art Gallery would like to thank Professor Bruce Brown, Dean of the Faculty of Art, Design and Humanities at the University of Brighton, for the support which he gave at all stages of the preparations of both the Brighton exhibition and this book. We offer our sincere appreciation to all of the book's contributors, and to the Directorate of the University of Brighton, who supported the publication with the utmost generosity.

In conclusion, special gratitude is owed to Iain Roy, of the University of Brighton, and Jane Alison, of the Barbican Art Gallery, for all that they have contributed to the selection and organisation of our respective exhibitions during this most fruitful and pleasant collaboration between our galleries.

JOHN HOOLE Barbican Art Gallery
MICHAEL TUCKER University of Brighton

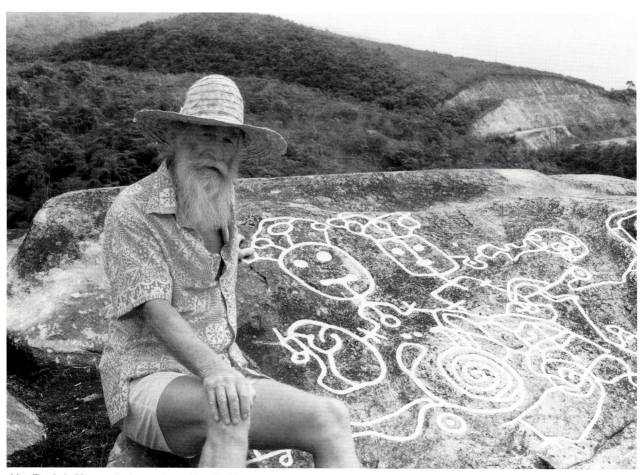

Alan Davie in Venezuela, late 1980s, with a Carib petroglyph *c*.3000 BC

Visions of an enchanted life
Michael Tucker

One of Alan Davie's recent paintings bears the intriguing legend (and title) *Formula for the constitution of the liberated spirit* (cat.9). In a free-floating landscape of the soul, a mandala-like combination of circles and bars of glowing colour conjures the architecture of a quest for the miraculous – for the transmutation of matter into magic, in the evocation of the (rationally) inexpressible. Reminiscent of aspects of Tantric art, the image and text of this 'psycho diagram', as Davie has further inscribed the work, hover above a fabulous sky-blue ground. The total ensemble intimates the sort of rare and luminous moment when one's sense of life – of the deepest currents of one's being-in-the-world – attains that kind of integrated, exalted state spoken of by philosophers of religion and mythology and humanist psychologists alike. This is the moment which is simultaneously transcendent and centred, as rooted in the nurturing reality of the earth as it is open to the transformations of celestial mystery.

Many years earlier, Davie had begun his travel journal of 1948-9 by recording how, early one evening, he had been filled with 'the strange drowsiness that brings a vision of an enchanted life in a land of fantastic beauty'. And then, he continued, had come the recurring visions of 'an inner beauty somewhere beyond the conscious impressions created by light through the lens of my eye'.[1] From his late adolescence onwards, whether painting, writing poetry or playing music, Davie has sought that inner beauty, those visions of an enchanted life. Like the Dadaist Jean Arp, who spoke of how he hoped his work might help people to dream with their eyes open, Davie views art not as an end in itself, but as a vehicle to a deeper and richer experience of life. To encounter the nourishing, shape-shifting world which Davie has created over the past fifty years is to enter a universe of potentially transformative reverie – the condition which the French philosopher Gaston Bachelard considered to be the truest indication of the depth and breadth of our psyche, our being-in-the-world.[2]

At least one spiritual tradition which has meant much to Davie over the years – the Taoist-inflected tradition of Zen – suggests that only by the complete absence of divisive mental activity can one reach this state of dreaming wakefulness, of the enlightenment which sees through the imprisoning world of dualistic concepts to the ultimate, surpassing unity of life's energies. 'Illusion makes the world close in; enlightenment opens it out on every side' claims the Zen seer. The insights of the cave artist, of the alchemist and the shaman have been of no less importance to Davie in his quest for the miraculous, his pursuit of those visions of an integrated and enchanted life. He recently summed up a lifetime's work in the following words:

Basically the creative state would appear to amount to a kind of religious communion with the GREAT ETERNAL. Here it is apparent to me that what I am doing is fundamentally the same as artists of remote times – the same as artists in tribal society – engaged in a shamanistic conjuring up of visions which will link us metaphorically with mysterious and spiritual forces normally beyond our apprehension.[3]

To speak of 'visions of an inner beauty', of forces 'normally beyond our apprehension', and to parallel the (potentially integrative) activity of painting with the shape-shifting quests of the shamans, or seers and visionaries of prehistoric and tribal culture, is to focus on matters very distant from the interests and constraints of the (largely) Marxist- and Durkheimian-inspired sociology of art that would claim dominance of the discussion of many cultural issues today. Here, 'gendered language' and 'the politics of the personal' address the social facts of the postmodern potentialities opened up by the post-Barthian death of the (allegedly) once-omniscient author.[4] Little could be further from the clear and hard-won shamanic overtones of Davie's vision quest – from his belief that 'One must learn to have faith in the intuition which "knows" without knowledge'[5] – than the current proliferation of sociological commentaries on painted and sculpted 'texts', of so much 'discourse about' and 'deconstruction of' meaning in the contemporary art world.[6]

This is a world obsessed with the textures and the tensions of history and politics, a world which would often seem able to see (or rather, to 'read') art only through the 'politically correct' lenses of its fashionably tinted spectacles. Of course we live in history; of course that 'we' is problematic; of course the imperatives of history (or as some may prefer, Herstory) and politics press upon us now as never before. But ours is the first culture to proclaim with hubristic certainty that history

and politics together constitute *the sole ground* of our being, and that any sense of the 'vertical' or 'cosmic' dimension in life is but a reactionary remnant from the irrationalities of pre-Enlightenment thought.[7]

A good part of the considerable value of Davie's early travel journal – which until now has only been available in the form of the various short quotations and paraphrases which the art historian and curator Douglas Hall supplied in his recent overview of Davie's life and work[8] – lies in the extent to which it reveals a mind able to see what might be called classically Modernist questions about art's presence and power within an essentially Romantic context of pan-religious spirituality. In recent years, several publications have suggested that it is high time that we stopped stressing Modernism's ostensible formal and ideological break with the past, to focus instead on the many structural links of intention and effect which might be discerned between the Romanticism of the late eighteenth and nineteenth centuries and the innovations of the twentieth-century avant-garde.[9] From the point of view of religion, mythology and hermeneutics, the most important of all such links is the shared sense of unease concerning the desacralisation of life, and a concomitant desire to 'respiritualise' existence: to develop, that is, the implications of the insight of the late Mircea Eliade, the distinguished philosopher of religions, that 'the "sacred" is an element in the structure of consciousness, not a stage in the history of consciousness'.[10]

Shortly after the Second World War, Eliade (1907-86) spoke of the dangers involved in the 'complete historicisation' of twentieth-century life, of the potential negation of humanity's capacity for what Eliade called 'spiritual spontaneity'. While we live in history (or rather, our understanding of that deceptively simple term), it is also the case, argued Eliade, that we have the ability to open ourselves to *other* dimensions of existence, dimensions which can only be called 'cosmic', or mythopoeic.[11] Wittgenstein believed that the limits of our language are the limits of our world: however, when one raises one's arm to point to the moon, the gesture is usually not intended to draw attention to the condition of one's fingernails. For Eliade, the deepest 'gesture' of art lay in its intimation of Paradisal consciousness, a (trans-historical) state acknowledged, hymned and pursued *symbolically* by all cultures previous to our own. (And what have we done but attempt to historicise mythology, in the sort of perverse alchemy of fact which would turn symbol into sign, myth into matter?)

'Though we cannot conceive man as other than an historical being', wrote Eliade, 'it is no less true that by his very nature man opposes himself to history, strives to abolish it and to rediscover, by every means, a "timeless" paradise in which his situation would be not so much an "historical situation" as an "anthropological" one.'[12] For Eliade, to speak of an anthropological situation was to speak of certain structural constants underneath the diverse flux of circumstance and history. It was to speak of the play of the concepts of the sacred and the profane in consciousness, of the central role played by the concept of the sacred generative centre, or *axis mundi*, and the subsequent openness to the 'vertical' dimensions of life, above and beyond (although also regulating) the horizontal, or socio-political realm.[13]

The chief aim of all Marxist-inspired sociology and politics has been to 'demystify' or 'deconstruct' the vertical dimension in life, to turn religious consciousness – the so-called opiate of the masses – into political consciousness. For Eliade, the point at issue was our culture's increasingly desperate need to effect exactly the opposite, to seek what he called 'a demystification in reverse; that is to say, we have to "demystify" the apparently profane worlds and languages of literature, plastic arts, and cinema in order to disclose their "sacred" elements, although it is, of course, an ignored, camouflaged, or degraded "sacred"'.[14] Such a goal did not condemn Eliade to any restrictive literalism or conservatism, as has sometimes been the case with other authors interested in the esoteric or 'occult' dimensions of art.[15] On the contrary: Eliade's understanding of the regenerative dialectic of creation and destruction in much so-called prehistoric culture enabled him to intuit what he called the replenishing sense of 'cosmic religion' implicit in much avant-garde activity this century, activity which he related to sacred archetypes, rather than – as in most histories of twentieth-century art – an exclusively historicising perspective.

Alan Davie is arguably the finest example of a twentieth-century painter in the West embodying an Eliade-like transition from history to cosmos in his work. Late in life, the great Bengali poet and painter Rabindranath Tagore (1861-1941) suggested that 'Only the true artist can comprehend the secret of the visible world and the joy of revealing it'.[16] Davie's travel journal reveals a mind seeking the key to that joy in the relation of the visible to the invisible, in the orchestration of living and lovingly perceived detail within a growing sense of the mystery of the cosmic whole. Posing some of the eternal 'transcendental' questions of life, the young Davie reveals himself to be as simultaneously humbled and exalted by the subtle richness of the play of light and shadow upon a country wall as he is jointly benumbed and inspired by the majesty of the Alps. Nothing could be further from that

sense of terminal historical alienation which had recently become so dominant in Europe, and which the art of Francis Bacon had already come to epitomise with such darkly magical aptness.[17]

Reading Davie's journal, one encounters exceptionally keen visual and musical sensibilities. It is worth remembering that, by the time he came to write the journal, Davie had already written a good deal of fine, Eastern-tinged poetry (some of which has been published in the 1967 and 1992 monographs on the artist) and had been a professional jazz musician.[18] Much in the journal develops the synaesthetic qualities revealed in Davie's poetry – and in his earlier Notebooks, as in this extract of 23 December 1943:

My eyes grow weary with writing words that should be music. Beginning, soft like the waving tall ones and soft like two small soft breasts, and cool like a slender hand rustling my hair untidy and grassy behind a clutching kiss. Music softly changing with the changes of windnotes whistling against the leaking door and rumbling and dying, and then the sunshine from out of a green air of winter, cast shadows, pale violet over bark, twigs budding.[19]

In Davie's work, sensuous and spiritual energy have always flowed together, nourishing a soul in wonder: a soul sensing part upon part of what Wols was to call 'the nameless love' that lies beyond all private loves. This is the love that psychologists such as James Hillman have talked about recently with regard to the Jungian concepts of anima and ensouling energy: the love that Rabindranath Tagore hymned with such affecting simplicity in his *Gitanjali* (Song Offerings) of 1912, for example, and to which, centuries previously, the Sufi Muhyí'ddín Ibn Al-'Arabí had committed himself with equally compassionate faith: 'O marvel! a garden amidst fires!/My heart has become capable of every form ... /I follow the religion of Love; whatever way Love's camels take, that is my religion and faith.'[20]

In 'purposeless pursuit' – as the Zen master would say – of those epiphanic moments that might restore some sense of cosmic balance to the historicised psyche, Davie has looked long and hard at an enormous amount of art. And in thus looking, he has sensed much of the trans-historical intensity within that essential 'cosmicity' which so concerned Mircea Eliade. In a 1991 interview with Andrew Patrizio and Bill Hare, Davie was asked why he was so attracted to primitive and non-Western art. Stressing how much the sophistication of primitive art is 'anything but primitive', Davie spoke of how

There are certain images in art (it doesn't matter where the art comes from) which are incredibly moving for some unknown reason. The things in art which are most moving for me are the arts of so-called primitive people, art of other cultures and ancient art, right back to the Stone Age.

Particularly in primitive art there seems to be some kind of spiritual intensity, if one can call it that.

He continued: 'And it's that kind of intensity which I feel all great art should have, in fact all great art has it. I mean, Picasso, Rembrandt, Uccello, Trecento painting, right back, it always has to have that. Primitive art also has this dynamic quality, intuition and a tremendous intensity.'[21]

Just as Eliade's sensitivity to the cosmic dimension in tribal and pre-historic existence did not condemn him to any literalising conservatism concerning twentieth-century life, so has Davie's enthusiasm for the art of the past always eschewed any sense of historicising revivalism. In Davie's bold, risk-taking work, the spirit of the old has always been made *new*. In 1960, at the end of the decade of wondrous work which established his international reputation – Douglas Hall speaks rightly of the 1950s as the 'epic decade' of the painter's career[22] – Davie revealed his now-familiar, Zen-inflected hope that some day one might be able to burst through the deadening historical carapace of life, given that 'In time perhaps an "inner knowing" can be cultivated to supplant the dead knowledge which is of the past, yet which continues to rule the lives of men in a lingering age of materialism; and perhaps through art man will rediscover the mystical key to the magic that is life'.[23]

For all his emphasis on intuition and direct action, on the knowing which knows without knowledge, Davie has never been afraid to set pen to paper in a relatively reasoned – albeit poetic – attempt to convey something of what that 'mystical key' and 'magic' might entail. Such texts as 'Notes by the artist' (1958), 'Towards a new definition of Art' (1960), 'I confess' (1963), 'Artist's statement' (1963) and 'The artist's experience of Art' (1966) remain of great value.[24] For Davie writes with striking, distilled lucidity, from out of a deep experience of art, of the ceaseless struggle to bring at least a fragment of the miraculous into painterly being, and to understand art as what one might call both ritual act and cosmic service. In 1958 he wrote: 'When I am working, I am aware of a striving, a yearning, the making of many impossible attempts at a kind of transmutation – a searching for a formula for the magical conjuring of the unknowable. Many times the end seems just within reach, only to fly to pieces before me as I reach for it.'[25]

It is to the great benefit of us all that Alan Davie has never held on to any such formula for long, has never settled for any recipe – that he has had to search and search and search again for the artistic and spiritual realisation of the visions which appeared to his inner eye so long ago. For that search has become his path in life, a path full of struggle and wonder, of the

transmutative joy of ... the search itself. The psychic foundations of that pathless path were laid early in Davie's life: in 1963 he recalled how 'The child born in Scotland in 1920 shared with all children the intense visionary powers, fears, fantasies and terrors of true knowledge which is really of the animals and therefore nearer to God than man'.[26] Somehow, Davie has managed both to preserve and develop that childlike sensitivity to 'intense visionary powers', powers balanced on the transformative axis of terror and joy. It is a sensitivity which runs right through the travel journal of 1948-9.

In 1948, shortly after his marriage to Janet (Bili) Gaul, Davie finally took up the Andrew Grant Travelling Scholarship which he had been awarded seven years earlier by Edinburgh College of Art. The Davies' year-long travels took them from Edinburgh to London and then on to their first experience of Europe: Paris and Geneva, Zermatt and Milan; Venice and Florence, Pisa and Antibes, Barcelona and Granada. By the time they turned back for Paris and London, Davie's commitment to art – which the artist has always apostrophised with a capital A – had become total. From that day to this, the painter's devotion to Art has been shared, supported and nurtured by his wife Bili, with unsurpassable stamina and grace.

Throughout the travel journal, which doubled as a series of letters to his father and a report for Edinburgh College of Art, Davie's language is as meticulous as it is poetic. His words convey the myriad visual and psychological impressions supplied by a series of fructifying initiatory encounters with metropolis and museum, mountain and Mediterranean, church and hill town. Davie also noted his own quickening thoughts on the need for a renewed spiritual dimension in art, an art which he believed had to be totally free of any sense of spiritual ostentation or mere cleverness of effect. Such art could only emerge from the primal, metamorphosing mysteries of the psyche – mysteries which this European sojourn did much to help stimulate and develop in Davie – and from a fundamental sensitivity to what Davie calls 'the Poetic mood'.[27]

Douglas Hall rightly dismisses the idea that the (largely enthusiastic) thoughts which Davie committed to paper from 6 April 1948 to 30 March 1949 should be seen as evidence of a somewhat youthful and naive idealism, which the artist was somehow to grow out of later in life. As Hall maintains: 'Davie's life and work is a seamless web, and the pattern of it is revealed for the first time in this journal'.[28] To what extent might that pattern be related to particular historical precedent? Understandably, some readers of the journal may discern echoes of Ruskin in Davie's

encounter with the sublime in Switzerland, just as others might sense the spirit of Clive Bell and Roger Fry within the strongly primitivistic tenor of Davie's various preferences in the museums and churches of Italy and Spain. However, the reflections of Bell and Fry upon the trans-historical mysteries of 'significant form' were in fact as unknown to Davie at the time he began the journal as the writings of Ruskin or the ideas of Klee and Arp. (To this day, Davie has not read Ruskin. A journal entry of 15 January 1949 records his gratitude to his father for sending him a copy of *Paul Klee on Modern Art*; a fortnight later, Davie expressed his delight at encountering the ideas of Arp and Ernst for the first time.)[29]

The journal is chiefly notable, in fact, for the extent to which it reveals an affirmative, truly original – and from a structural, 'cosmicising' point of view, aboriginal – temperament beginning to shape itself, albeit with regard to the ideas of intuition and improvisation which had long concerned the Western avant-garde. Has any other painter done as much to resurrect what Eliade called our capacity for 'spiritual spontaneity'? In Davie, painterly, poetic and musical abilities and affinities have combined as potently as feelings for both the diverse (and often humorous) details of life and the grand design of things. A Western, near-Baroque sense of terror and drama (which makes the dislike of the Baroque revealed in the journal somewhat curious) has flowed into an essentially shamanic celebration of life's transformative mysteries; an Eastern, ego-less sensitivity and a vibrant celebration of sexual energy and metamorphosing fecundity have together conjured the cosmicising, 'vertical' miracle of pictorial and psychological mystery.

If art *is* made with the whole being, as Davie believes it must be, it surely can embark on a quest for the miraculous. And if it is not, what real need have we of it? The Nigerian poet Ben Okri has recently suggested that, if we do not somehow 'Recharge the psychic/Interspaces/Of our dying/Age', we will continue to live but a half-life, 'Divorced from/The great dreams/Of the magic and fearful/Universe'.[30] Nearly half a century ago, Alan Davie began to get in touch with such dreams: with those 'visions of an enchanted life' which, ever since, he has meditated upon and brought into the world with such tireless courage and noble generosity of spirit.

Notes

1. Journal entry of 6 April 1948, London. I am grateful to Alan Davie for the access to both his travel journal and his earlier Notebooks which he kindly gave me in winter 1992-3. The journal was originally titled 'In quest of a philosophy of beauty': in a recent interview, Davie suggested that his work might be better thought of in terms of 'a quest to find the miraculous' (A. Lambirth, 'In conversation with Alan Davie', *The Artist's and Illustrator's Magazine* Issue 76 January 1993 p.20). In the same interview, Davie spoke of how 'Art must have universal significance beyond the expression of the self. Art is produced by the complete integration of a whole being' (ibid p.19). Almost fifty years earlier, a Notebook entry of 19 December 1943 had revealed Davie's belief that 'The great works are made from life itself, stripped of superficiality and impurity; they are pure soul and joy, delicately like the delicateness of line across immense mountains'. See H.-G. Gadamer, *The Relevance of the Beautiful and Other Essays* (ed. and with an Introduction by Robert Bernasconi, trans. Nicholas Walker, Cambridge University Press, Cambridge and New York 1991) for an important series of reflections upon art as play, symbol and festival, reflections which, in their closely reasoned, yet poetically open insistence that 'the work of art signifies an increase in being' (p.35), bear strong comparison to Davie's views on art and its essential relation to the deepest forces of life.

2. See G. Bachelard, *On Poetic Imagination and Reverie* (ed. and trans. Colette Gaudin), Spring Publications Inc, Dallas 1987.

3. *Alan Davie* with essays by Douglas Hall and Michael Tucker, Lund Humphries, London 1992 p.82.

4. I do not mean to imply that such approaches are without value: see for example the various articles in R. Ferguson, W. Olander, M. Tucker & K. Fiss (eds), *Discourses: Conversations in Postmodern Art and Culture*, The New Museum of Contemporary Art, New York/MIT Press, Cambridge, Mass. and London, England 1992. However, a good deal of (essentially sociological) postmodernist discourse seems to me to be based – like Suzi Gablik's well-known critique *Has Modernism Failed?* (Thames and Hudson, London 1985) – upon a less than complete perception of Modernism. What one might call the transformative concern for the regeneration of the sacred amongst diverse Modernist artists has often been neglected in favour of a critical formalist/techno-Utopian reading of a supposedly monolithic Modernist/Eurocentric ideology. The various deconstructions of Barthes-, Foucault- and Derrida-inspired postmodernism need to be balanced – at the very least – by an awareness of other, older perspectives upon the question of 'trans-individuality' in art, such as are supplied, for example, by the works of Joseph Campbell, Mircea Eliade and Erich Neumann: all of which parallel Davie's belief that worthwhile art is a product of the whole self, or what Jungians call the individuated, or Great or Cosmic Self. For an application of Jungian and shamanic ideas to Davie's work, see M. Tucker, 'Music man's dream' in *Alan Davie* 1992 op.cit. pp.71-92, and M. Tucker, *Dreaming with Open Eyes: The Shamanic Spirit in Twentieth Century Art and Culture*, Aquarian/HarperSanFrancisco, London 1992 pp.320-6 and passim.

5. A. Bowness, *Alan Davie*, Lund Humphries, London 1967 p.14. Quoted from catalogue *The Developing Process*, ICA, London 1959.

6. See for example S. Hiller (ed.), *The Myth of Primitivism: Perspectives on Art* (Routledge, London 1991) for a series of attempted deconstructions of the so-called 'myth' of primitivism. Surprisingly, Davie's work is not mentioned at all here; nor are the key ideas of Joseph Campbell and Mircea Eliade. See the discussion of primitivism and its recent critics in Tucker 1992 op.cit. (*Dreaming*) pp.3-9.

7. See ibid pp.27-37.

8. D. Hall, 'Introducing Alan Davie' in *Alan Davie* 1992 op.cit. pp.7-32.

9. See for example J. A. Argüelles, *The Transformative Vision*, Shambhala, Berkeley 1975; A. Wiedmann, *Romantic Roots in Modern Art*, Gresham Books, Old Woking 1979; M. Tuchman (ed.), *The Spiritual in Art: Abstract Painting 1890-1985*, Los Angeles County Museum of Art/Abbeville Press, New York 1986; J. Lane, *The Living Tree: Art and the Sacred*, Green Books, Hartland, Bideford 1988; R. Lipsey, *An Art of Our Own: The Spiritual in Twentieth Century Art*, Shambhala, Boston and Shaftesbury 1988; and Tucker 1992 op.cit. (*Dreaming*).

10. M. Eliade, *The Quest: History and Meaning in Religion*, The University of Chicago Press, Chicago and London 1975, Preface (unpaginated).

11. See M. Eliade, 'The sacred and the modern artist', *Criterion*, Divinity School, University of Chicago 1965 vol.4 pt 2, and Tucker 1992 op.cit. (*Dreaming*) pp.73-5 and passim. Compare Gadamer 1991 op.cit.: 'Every work of art imposes its own temporality upon us ... in the experience of art we must learn how to dwell upon the work in a specific way. When we dwell upon the work, there is no tedium involved, for the longer we allow ourselves, the more it displays its manifold riches to us. The essence of our temporal experience of art is in learning how to tarry in this way. And perhaps it is the only way that is granted to us finite beings to relate to what we call eternity.' (p.45)

12. M. Eliade, *Images and Symbols: Studies in Religious Symbolism* (trans. Philip Mairet), Princeton University Press, Princeton, New Jersey 1991 p.122 (first published 1952).

13. See M. Eliade, *The Sacred and the Profane: The Nature of Religion* (trans. Willard R. Trask), Harvest/Harcourt, Brace and World Inc, New York 1959; and Tucker 1992 op.cit. (*Dreaming*) pp.267-71.

14. Eliade 1975 op.cit. p.126.

15. See for example F. Gettings, *The Hidden Art: A Study of Occult Symbolism in Art* (Studio Vista, London 1978 pp.160-1) for a 'fundamentalist' misunderstanding of the allegedly decorative qualities in Davie's work, and the discussion in *Alan Davie* 1992 op.cit. pp.84 and 91.

16. Quoted from a letter of 1941 to the painter Jamini Roy in A. Robinson, *The Art of Rabindranath Tagore*, Andre Deutsch Limited, London 1989 p.53.

17. It is typical of Davie's sensibilities – and

sensitivity – that he reacts strongly to any idea that Bacon – or any other painter – be 'reduced' to merely sociological status, as it were. Rather than registering the horror which many commentators (including myself) have professed to see in Bacon's work, Davie relishes what he calls the 'magical quality' in Bacon's pursuit of the compelling image. Personal communication, February 1993.

18. On Davie's jazz career, see M. Tucker, 'Music man's dream' in *Alan Davie* 1992 op.cit.

19. From *Collected Contemplations* vol.4 p.140, privately printed.

20. See J. Hillman, *The Thought of the Heart* (Eranos Lectures 2), Spring Publications Inc, Dallas 1987; R. Tagore, *Gitanjali*, Papermac/Macmillan, London 1986 passim; and M. Ibn Al'Arabí, *The Tarjumán Al-'Ashwáq* (trans. Reynold A. Nicholson), Royal Asiatic Society/Theosophical Publishing House, London 1978 p.67.

21. 'An interview with Alan Davie' in *Alan Davie : Works on Paper*, Talbot Rice Gallery, Edinburgh/British Council, London 1992 pp.35-6.

22. *Alan Davie* 1992 op.cit. p.22.

23. Alan Davie 'Personal thoughts', *The Times Educational Supplement* 24 June 1960.

24. These texts are available – together with the painter's 1991 'Notes on colour' – in *Alan Davie* 1992 op.cit.

25. ibid p.50.

26. ibid p.54.

27. Entry of 21 August 1948, made at Assisi. Compare Rudolf Steiner's belief that 'If we wish to reawaken in mankind the true artistic mood, we must, to a certain degree, transport ourselves back into those ancient times, when the celestial, the poetic mood, lived in the human soul'. Quoted in J. H. Moffitt, *Occultism in Avant-Garde Art : The Case of Joseph Beuys*, UMI Research Press, Ann Arbor and London 1988 p.167.

28. *Alan Davie* 1992 op.cit. p.10.

29. Personal communication February 1993. On 'significant form' see C. Bell, *Art*, Perigee Books, New York 1981 (first published 1913), and R. Fry, *Vision and Design*, Oxford University Press, London 1981 (first published 1920). On the spiritual/psychological significance of the concept, and criticisms of it, see for example the discussion in Tucker 1992 op.cit. (*Dreaming*) pp.53-4. Although Gadamer (1991 op.cit.) does not mention the idea of 'significant form' as such, several of his insights – in particular those developed from reflections upon the aesthetic philosophies of Aristotle, Kant, Hegel and Heidegger – would surely prove fruitful in any contemporary elucidation of the concept.

30. 'Lament of the images' in B. Okri, *An African Elegy*, Jonathan Cape, London 1992 p.13.

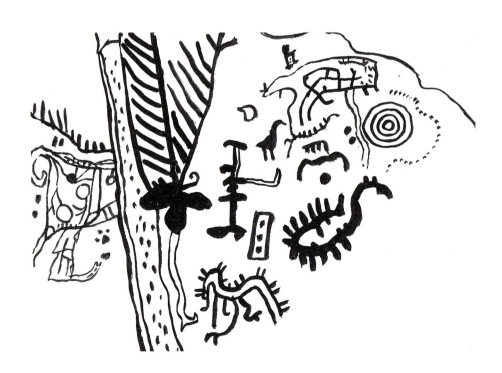

Extracts from the travel journal of Alan Davie 1948-9

April 6 1948, London

As the evening window is closed leaving a mere chink of apple green sky against the trees behind us, I am filled with the strange drowsiness that brings a vision of an enchanted life in a land of fantastic beauty. The passing scenes are indeed so enchanting, even beyond description, to my intoxicated eye. And then come the recurring visions of an inner beauty somewhere beyond the conscious impressions created by light through the lens of my eye .. it is a beauty so fine and so clear .. whence does it come, and why does it push itself with such creative power into suggestions of form .. into a line of nostalgic notes for flute in a low register [...] into an incomplete fragment of word poetry .. into a visionary flash of colour mass?

April 7

Galleries Redfern, Marlborough, St George, Reid and Léfèvre, London. What a mass of rubbish is on show under the name of Art. Hidden amongst it, an occasional glimpse of genius .. a small Sutherland landscape, a tiny coloured Picasso, a colotype by Miró, *L'été*, like a breath of summer sunshine, clear and exact in its form .. a breaking wave on a perfect sea .. summer figures on a yellow sand and an inquisitive moon. The print gives a perfection of colour mass unobtainable by brush.

April 8

Surely never before was there such chaos in the world of thought; never before was there such a lack of something to believe in. We who are young are the incredulous ones. We ask one another: 'What is the use of living?' 'Is peace merely a breathing space between wars?'

April 16, Paris

In the Louvre there are some pieces of pure joy ..

April 24

It is difficult to find amongst the masses of works by artists of the present day anything which might be ranked with the best from the past. It is even more difficult, perhaps, to find a reason for the decline in production of major works of Art, in a period of history which is notable for a widespread development of the intellectual mind. Mental or spiritual growth in the process of evolution always precedes the growth of physical ability; leaps ahead of it leaving it far behind like a stubborn child. Great works are only produced when there exists a balance between abstract conception in mind and material ability to give ordered and understandable form to it. It is therefore reasonable to assume that the more advanced and specialised developments of mental processes so rapidly taking place in this age, are becoming more and more isolated from any substantial form which can easily be used as a vehicle for their full expression. I can feel the approach of an age when mind will not be dependent upon matter for its existence but will live a full and unhampered life in a world of spirit. Is it, then, the half conscious awareness of this that makes the modern thinker dissatisfied with his own work? He is surely become over-sensitive. In a search for a satisfactory solution to the problems which thus beset him, the poet must not produce a strain by over much striving to be forever better and different and more intense; it is only by being in essence simple of heart that he can ever hope to produce something out of the marriage of spirit and form [...]

April 26

The filth and the oil and the bottle corks sail steadily down the river rising and falling slightly; long barges pulled by tugs sail quickly upwards below the bridges and the little fishes flick the plane where air and water press together so that sparks fly and little ripples run. The music of the city moves onward also. Sound moves always in one direction only .. never backwards .. ever forward .. the four notes of a sparrow rising up over the river shall never again be heard .. sounds which are born and die within a second of time .. rattle and hoot of horns, some high, some low in pitch, some rough, some merry, some angry .. the whistle, the bell, the shout and the bark .. the rustling of leaves is mingled always with the ceaseless chattering of birds. The sun sinks lower, leaving a spray of rainbow mist like a fine net over the shadows.

April 28

The Exhibition of Impressionists in the Jeu de Paume contains a mass of third-rate daubs and a number of

works of genius. Paintings by those who devoted their lives to the production of optical illusion in effects of light and atmosphere and had little time for creative philosophy or intelligent observation of fundamental reality. The few great men of the period were invariably the simplest. It is like a refreshing shower of rain on a hot day to come upon a small Van Gogh landscape amongst a meaningless mass of spotted pinks and blues and mauves like a fog [...]

[...] Some of the Degas canvases are infinitely more fine than I had anticipated, particularly paintings of the race meetings .. his drawing is nothing less than miraculous, and the quality of paint in the silks of bright coloured jockey costumes equally astonishing [...] The Gauguins of course have an undeniable character which will live for ever: like Buddhas carved in a rock face they look out upon the world with the calmness of eternal divinities.

[...] Perhaps the most impressive piece in the Jeu de Paume is *War* by Le Douanier Rousseau. Its strength is also in its simpleness .. its vital growth of black pattern .. the powerful forward movement of the rider's horse, neck outstretched, in mad flight over the mutilated corpses strewn about, and the carrion crows hopping amongst the dead.

April 29

The beautiful qualities of light in the Jardin de Luxembourg, the pink and white chestnut blossoms, the trimmed green avenues, the fountains, the greys and pinks and salmons and blues, almost make one wish to join the throng of artists sketching and painting there. Yet I feel so strongly, with such an intensity in the envelope of qualities, so surrounded by sights and sounds and perfumes, so much absorbed into the sunshine and the sky, a drawing would be like a mere scratching of a hen's claw. The absorption of life experience through bodily sensation takes place in the deep cool darkness of my brain like a bee-hive; images are traced there in an immense network of strands pure and white like finely drawn worked lace, no thread touching another. When the womb of my brain is ripe for intercourse, my mind shall become pregnant and shall deliver with great pain a child into my hand.

May 2

I came forth out of the haze of smoke and stale smells of the Bar Vert and stood in the cool clear crystal air of night, and all the reflections which rushed to me .. from the stars and the sky's bowl, from the lit windows in the bulging buildings, from the pale green lamp lights, from the purple wet street .. all centred me as the pivot around which revolves the whole universe of which I am eternally an integral part.

May 7

At night when the faded curtains are pulled over the dark window, the coffee is in the pan to heat over a tin of wood alcohol which burns with a gentle blue flame, there is a restfulness about me .. I can relax after the brightness of the day and contemplate without interruption. The images which appear in my mind are as real as those produced by optical processes. Is it possible then, that a mental image is but a reflection, or perhaps some kind of print or reproduction of a visual sensation which has been caused in turn by a reflection from an object or series of objects within my visual range. My ability to conjure up at will the appearance of any one of these subjects suggests to me that the true form of a work of Art is not merely that of the painting as we usually know it, or of the matter which has been organised by the artist at the time of production, but can exist even after the canvas has been destroyed and can be enjoyed then and discussed and appreciated by all those who have seen it .. even to have seen it is not necessary .. for one can enjoy almost as well from a good photographic reproduction. Surely that spiritual joy which flows in us from the vision of a fine work comes not from a mere arrangement of material forms .. surely the illusive quality of beauty is something which exists outside space and matter, in a world of timeless spirit, and the picture is only a materialisation of such spirit .. a manifestation of spirit felt by a creative genius and passed to us through its conducting medium of form, as a wire can conduct electrical energy from one matter to another. The true essence of spiritual beauty is indestructible and everlasting.

Those flowers which look at me and fill me with joy by their pure beauty .. is not the plant which produced them worthy of as much praise as Jan Van Eyck or Uccello, Botticelli, or Pieter Brueghel?

Nature is the first manifestation of spirit .. from sensitive observation of nature the artist derives power for his own marvellous extension of natural force.

May 8

I have spent the better part of four days in the Louvre. My passion for certain works there continues to grow with each meeting. The stimulating effect upon the creative fibres of my mind is difficult to analyse. I pass from one picture to another until suddenly I find myself assailed by a supernatural presence which settles itself about my head and over my body .. I can see through it as though through clear glass .. yet everything becomes more clear than clear. Having experienced this change and the chemical reaction caused thereby throughout my whole body, I draw nearer to the picture and proceed to assimilate

particular qualities separately which together go towards the formation of the whole [...] Above all [when looking at Uccello] I realise the intense effect of simple colour harmony .. a harmony truly unusual: crimson, dark green, dull silver, purple, black, white.

A miracle .. a battle of Uccello.

May 11

[On looking at the work of Hieronymous Bosch] .. the mad ones have a clarity of vision and directness of expression common to all creators of genius. Is not genius but a madness: the creator in a wild outburst of joy, conscious only of the purity of his own individual vision and oblivious to his surroundings, becomes a superhuman creature, an abnormal mad being, capable of supernatural conception and the direct perception of dream imagery ..

Brueghel is the great painter of landscape .. an artist who contains nature within himself and is himself an intimate part of nature. The orderliness and perfect blending of trees and flowers, birds, beasts, houses, hills and sky into a glorious picture is the product of his profound understanding.

May 13

Being submerged and thoroughly steeped in the beauty of the early Italian school and the simplicity of the Flemish and Dutch masters .. the bewitching *Mona Lisa* of Leonardo, Francesco di Giorgio's *L'enlèvement d'Europe*, the least sophisticated Botticelli *Vierge et enfant des anges* .. Bernardo Daddi, Giorgione, Jacopo Bellini, Terboch, Bouts, Van Eyck, Bosch and Brueghel: I could feel the natural inbreathing and outbreathing of the part of nature which I am .. in the reflection of nature from coloured canvases I could see myself cheerfully wandering amongst fields and cities; and when I was come again into the world I could feel the beauty around me begging like the little sparrows that come expecting crumbs when I have none [...] And having begun to draw on the river bank, I suddenly realised that it was possible for me to thrill with the joy of looking at and appreciating and soaking myself in beauties of represented reality, without being able myself to find any satisfaction for my expressionhunger in producing such representations myself. It was as if I had shouted into a dark tunnel and had no reply but my own echo bouncing emptily farther and farther into space. There was no reply. And then it was also that I realised that my mind was changing fundamentally and was developing new needs for new dimensions and I realised also that the form in which beauty clothes herself changes not by force of external environment but only by the force exerted by gradual change of brain shape through evolution.

Beauty, the constant factor, manifests itself differently through different mind mediums .. as the mind changes, the manifest form alters. Spirit force creates movement and change which alters by natural law without consciousness, in vegetable and mineral forms, and primitive animal forms which have not yet reached an advanced state of development; but in the case of man, the most highly developed, evolution no longer functions directly through matter, but now appears to be asserted through the most sublimated substance which is called mind, and works through the indefinable and elusive channel in the brain which we call consciousness, to a final shape in matter.

[...] At the moment, a reorganisation is taking place within me and having not yet found a proper balance between forces I find myself uneasy and dissatisfied with the material product of my efforts [...] I believe that it is only through long and laborious specialised work of an experimental nature that I shall be able to evolve a satisfactory symbolism with which to bring my new vision to light. In the meantime, by acquiring an immense fund of experience through travel and intimate research into the myriad manifestations of nature, I shall be the better equipped with subconscious material with which to work.

May 16

Utrillo is ever so gentle and friendly and happy. I should like to live with him.

May 23, Geneva

The road descends steeply in another winding zig zag from the highest point: there we saw the Swiss Alps for the first time. It is the most magnificent view I have ever experienced .. the great Lac Léman (Lake of Geneva) in a flat green basin and the towering white mountains and Mt Blanc behind shining in the sun behind rain clouds ..

May 26, Zermatt

The night found us in a chalet of scented pink pine wood .. around were the lights of the village and the silent sky full of dim dark forms amidst clouds. The desire to see the great Matterhorn possessed my brain .. many times in the night I raised myself to look out of my window. In half sleep I could see the sky now clear like lead .. there was a star as clear and bright as a blinding moon in frost.

At last there in the thick air I could see the dimly shining form of the Matterhorn, now clear of cloud, all lit with a supernatural whiteness in the night. My dreams were filled with its form .. the great triangular pyramid pulled up to a bent-over top, all covered in pure snow. I awoke after in the clear six o'clock

blueness and there it was all illuminated brilliant with the early morning sunshine and everything else still in the lingering shadow of night. It is the most wonderful thing I have ever experienced .. it is a thing as inexpressible as the moon and as mysterious and as full of awe. The terror of it grips me with a fear of space. The bigness of it fills my lungs with indrawn breath till I would burst with the clear air expanding my lungs. I stare at it till my eyes cannot see it anymore with tiredness and at evening time I sit to watch the sun setting until the only bright thing still reflecting light is the Matterhorn ..

.. The world sleeps and the great God watches over us all.

May 30

Words cannot possibly express the massiveness of this country .. it overwhelms me .. I am so speechless with it, its breathtaking beauty. The timelessness of mountains can perhaps only be expressed in terms of music .. and then the gentle sound approaches of a herd of goats, each her little bell tinkling, driven home from the hills in the evening by a little goatherd [...] Here also the fine cows lie in the sheltered darkness.

June 3

The miracle that comes to pass; the light which gleams suddenly within me, the flash of true understanding, for a moment blinding me, then filling me with a complete joy and satisfaction; it is so difficult to define, yet it forces me to try.

To find a medium suitable for the satisfactory materialisation of such 'vision' is the problem which besets my whole mind. This morning whilst walking in the magnificent gorge near the adjacent village of Tasch, I was deeply aware of the million beautiful living objects which were passing me, and particularly I wondered why the crisp green and red little colonies of saxafrage should choose the bare rock for their home when all around is a soil rich and moist. Under the rock also were several families of tiny fern. Whilst my eyes were full of the white rushing stream and the soft green of the pines I suddenly stopped and became aware of a tiny black and grey bird singing from a branch .. A little song in the midst of such wildness of rock, overcast with deep hanging cloud, in an air heavy with thick scent .. a little song of pure joy. That this bird is so exquisitely happy here, as I am happy, to be alive and to see the coloured mosses on the rocks and to be able to enjoy the pure delicate blue of the forget-me-nots that are sprinkled about this nearby sloping field; so much beauty is here, it is necessary to sing as the birds or to dance like the young goat kids. The peasants thankfully adorn the roadside 'vierge' with bouquets of rare flowers. Such a religous gesture is surely also an abstract expression of the reality which touches us [...]

It is easy to make the mistake of trying to express such visual beauty in a realistic manner. All that the skilful painter can produce is but a dull reflection, an expression not of beauty but of his own cleverness [...] No real beauty (and by beauty I mean that spiritual completeness which comes to the mind on the contemplation of visual beauty) can be satisfactorily conveyed directly, but that beauty which we seek, can only be extended through the subtleties and strange channels of indirect artistic media such as those of poetry and music. In painting, it is so much more difficult; this medium has few of the thoroughly organised laws which have been evolved for the government of musical creation and even for the production of form in language.

Painting has so much more scope and freedom in its wide variation of colours and shapes. So much freedom has the extremely individual mind in paint, that it can easily find itself blown amongst the winds of the vast spaces. It is necessary therefore that each painter must find for himself an individual symbolism of form and colour before he can begin to formulate an idea which can truly express the reality which fills his soul.

I must make it clear that an idea is not an end in itself, nor is it something from which artistic work shall find a beginning, but it is truly something through which beauty can be expressed and which shall be embodied in the final work and possibly, as often is the case in my own work, shall only appear even to the creator *after* he has completed that work.

Admittedly a certain admirable form of sweet beauty and simple loveliness can be expressed by a realistic directness. Such is the true beauty of the early Chinese poetry and that of the late imagists of our own language .. likewise are the sweet Dutch landscapes undeniably lovely. But, though I can appreciate and enjoy such simple beauty, there exists for me now a more immediate and infinitely deeper beauty than can ever be expressed thus.

It is towards the perfection of a personal symbolism for its expression that I shall pursue my own artistic work.

In Switzerland I have found a demi-paradise, a heavenly store of infinitely varied experience. Here, amongst some of the highest mountains of our world I have felt deeply the terror of vastness, the fear of death amongst the solitude of immense rocks, the spiritual awareness, the same sincere religious consciousness which caused the many wooden crosses on hill paths, the terrible cross on the summit of the Matterhorn.

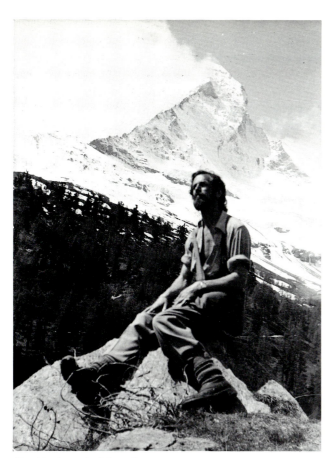

Alan Davie on the Matterhorn, 1948

Here, as nowhere else can be felt the true smallness of oneself in this vast universe [...]

Let it never more be said that Switzerland is of no value to the student or the artist. It is surely a deep mine of invaluable experience : a place of pure inspiration to the creative man who has eyes to see, ears to hear, and a nose to sniff .. above all, a mind with which to think.

For myself, I am convinced that my artistic mind has developed more in one week here than could have been attained after ten years in art galleries.

June 13, Milan

Here [the Basilica of St Ambrogio] there is sculpture of inestimable beauty [...] The interior is typical of early Christian style .. I am deeply moved by the sculpture, particularly the pulpit, all in carved stone with biblical scenes, pillars supported by lions .. the whole exquisite in proportion. Below the bible is a magnificent eagle, primitive and of Celtic flavour in metal [...]

.. I was amazed once more at the definite relationship existing between the greatest modern Art and the masterpieces of such early simplicity. Although apparently at first glance crude and primitive, the early Christian art has a true perfection of form and is certainly of the very greatest.

I rejoice in the hope that my own era shall witness a revival of primitivism and of simpleness.

June 21, Venice

The colour of Venezia is quite extraordinary. I have never seen anything like it. The water is a deep turquoise green speckled with little steamboats with red funnels, black gondolas, and fishing boats with bright orange sails. Yet there is a greyness over everything .. the sky is seldom a brilliant blue and the buildings on the shore mainly Naples yellow and grey and white and dull Italian red ..

.. Each day we are more and more in love with this place .. so much there is to see .. so much beauty appearing around each corner ..

June 25

What is perhaps the greatest exhibition of Modern Art ever held [Biennale di Venezia] has been the object of my whole attention during five whole days [...] The huge pavilion of contemporary Italian art itself contains fifty-one rooms, one of which is devoted to Paul Klee and another to Pablo Picasso. It is little wonder then that I am so exhausted and suffering from a kind of stimulation hangover after so much mental and visual exertion ..

[...] On Tuesday morning at four I was striken ill with sickness and colic and am now recovered although still somewhat weak and unable to eat much. Yet I have been able to make some thirty small drawings and to absorb the colours of the evening into the hollows of my brain. It is strange how during illness, visions of shape and colour come to my closed eyes, so varied and mysterious, changing with every recurring spasm. So bright and large they are and full of fine lines like silky fibres, minute tissues of the brain, leading to nerve centres, the innermost catacombs of the intestines, the subterranean caves lit with internal fires, brilliant and flaming, red and yellow and pale green, purple and blue, forever changing.

July 7, Padua

[...] one comes upon lovely early frescoes, several by Giotto and his pupils, naive primitive works, so much alive and so strangely real and genuine compared with the later rubbish which usually surrounds them [...]

July 16, Venice

[In the Accademia] I love particularly the early ones, of the late 13th and the first half of the 14th century .. the blending of stiff Byzantine with a more human softness, yet still decorative and as pure.

July 19

.. There is a marvellous completeness about these little paintings [of the 14th-century Venetian School, Museo Correr], as if they had been breathed by some supernatural power .. there is no mark of the hand of man [...]

.. Carpaccio's masterpiece .. *The courtiers* .. is completely beyond description, a miracle of metaphysics. The composition is a work of divine inspiration .. An expression of strange contemplation and sadness ..

.. Perhaps the most extraordinary composition of all is Antonello da Messina's *Christ held by three angels* (15th century) .. a composition of suspended weight, of hanging arms and a bent hand .. a composition of fine pointed wings against a deep, deep pale sky and a soft olive landscape. I am amazed (openmouthed) at the dark green-black of a little angel's robe appearing and disappearing behind an arm. The sharp points of the wings of the angel at the back, pierce my very heart.

July 30, Florence

After a strange exhaustion which kept me on my bed for seven days with not even enough strength to write, I have energy enough to walk as far as the nearby monastery .. a pilgrimage to the works of Fra Angelico. In this wonderful peaceful place there are many sweet spirits dwelling ..
[...] As one ascends the stone stair, suddenly there is a miraculous glimpse of an angel, so quiet and soft in a porchway .. her long wings many-coloured, stretched out behind her [...] I have yet to see a picture more moving or more simply lovely than this Madonna. It cannot be described in words.

July 31

The evening is exquisitely beautiful. At sunset I went out amongst the grey cedar trees that hang like dark nets against the rosy sky. The beauty of the calm pond and the lilies lying on the still reflections made me weep with infinite sorrow.

August 1

A picture [in the Galleria Pitti] which has stirred me perhaps more than any I have yet seen is the *Reclining Venus* of Titian (1538).

The quality of spiritual perfection is miraculous. When I stand before it exploring the softness of paint like a simple bird's breast, the extraordinary line which moves like the shadow of a cloud on a fine hill .. I am filled with wonder .. it is a miracle, utterly inexpressible, like the birth of a little babe or the germination of a seed.

[...] The beauty of drawing in the *Madonna and child* by Fra Filippo Lippi (1406-69) lies in the delicate and naive line and slightly distorted proportion .. how often is this distortion of natural shape evident in works of Art both ancient and modern .. the true art of drawing surely lies in the production of shape which is true not to visual reality, but to itself .. only the true creative artist has the marvellous ability to formulate his own true forms on his picture surface without being blinded by the optical sensations of realities which confront him in nature.

August 2

Painting is a much more mysterious Art than is generally believed. The adage that a painter paints just what he sees, is wrong. The adage that he paints what he feels is also not always correct. My painting of a man with fish is not in any way related to what I feel about a man with fish .. the fact that it resembles a man with fish is quite incidental and unimportant. Behold, it has now changed into two mysterious figures in the darkness .. now it changes again into three cats, now into a mountain landscape, now into a little child and a cat watching goldfish. I do not paint what I feel, I feel what I paint .. I do not create things, I discover them .. [...] The Art of painting, or for that matter, of any Art, is changed .. a picture is no longer of necessity a beautiful thing to live with or to look at (beautiful in the generally acknowledged sense) .. it must be a thing of more fundamental value, a thing of character and imbued with a power of its own, sometimes even a brutal or destructive power, but a life that is strong and growing and creative itself .. a thing which should be looked at with a different mentality .. a thing exciting and often even disturbing or frightening, yet having a beauty which is beyond beautiful.

August 3

The first room [of the Galleria degli Uffizi] contains a select few early altarpieces .. huge works by 13th- and 14th-century artists, two primitive crosses, one with a strange blue bent Christ by Cimabue (1240-1303) and another of the 13th century, dull colour against very pale gold. The drawing is so wonderfully simple .. the painting almost could be called 'modern' .. the monumental depth of spirit is truly gigantic. I shall return here many times. I cannot keep myself from dancing with joy [...] And as one walks through the successive rooms, so much is unfolden before the eyes: Simone Martini, Lorenzo Monaco, Giotto, Veneziano, Uccello, Fra Filippo Lippi, Ghirlandaio, Leonardo da Vinci (the early *Annunciation* and the unfinished *Adoration of the Magi*). Here at last I am able to stand before the *Primavera* of Botticelli. It is really beyond

description .. the colour and the delicate curves affect my brain like a drug .. I move on in a kind of trance.

There is so much in the Uffizi which I have always longed to see, so much which I wish to study till I know it intimately, to look and look, and to absorb and thoroughly digest until it becomes a part of myself.

August 5
It is difficult to combine in one's mind two entirely opposite kinds of vision: on the one hand, the perfection of the medieval painters, the early sculptural form of the early Renaissance .. on the other hand, a vague though steadily growing vision which is in a state of germination out of this age and perhaps the next; for the latter, although fundamentally related to the former in that it is also concerned with aesthetic beauty, is so entirely different as to be actively antagonistic to it within the brain. Therefore, being for the greater part of my working day confronted by the miracles and masterpieces of the old masters, I find it difficult to concentrate satisfactorily on my own painting; for it is concerned with a spiritual form, mostly religious in a symbolic way, which is more allied to the prehistoric and pagan symbolism as well as to fundamental early Christian forms than to later Catholic religious ideals.

As I move among the treasures of the Galleria dell'Accademia, there are marvellous things which are so exquisite and perfectly complete in themselves .. 14th- and 15th-century gems by the artists I admire more than any others: small altars by Bernardo Daddi, Taddeo Gaddi, Giovanni da Milano .. a marvellous *Annunciation* by Lorenzo Monaco in a perfectly constructed painted frame like the front of a porch. It is strange that I invariably find the earlier works more sympathetic to my own individual searchings.

Here is a room of Primitive works, Tuscan, Greek-Byzantine, early Siennese and Florentine, mostly of the 13th century .. strangely moving and powerful, primitive in colour and form, more symbolic in form and therefore more real in a basic sense although not so much related to the reality of individual personal characters.

As I continue my studies I become more and more convinced that I must spend a long time in a more detailed and specialised research into Byzantine, Romanesque and early basic Christian art.

So many of the works of Michelangelo that I have seen here are unfinished, can I dare to think that he also felt as I do .. he certainly is a sculptor who can be called modern .. the unfinished group of the *Deposition from the cross* with the strange exaggeration of proportions is very closely related to the works of Rodin.

I am forced to admit that the gigantic figure of *David* is the most impressive sculpture that I have ever seen.

August 6
Perhaps the greatest work [in the Church of Santa Croce] is the altarpiece of Cimabue with the figure of St Francis .. so ancient, yet somehow more moving .. the dark colours against the white-gold, the old dark reds, browns, black – the abstraction and formalisation of drapes and features, the vital drawing.

In the choir is a series of mural compositions of quite startling strength by Agnolo Gaddi, *The story of the tree of life* (1396). This is one of the many Christian legendary stories which I have recently gone to some trouble to find amongst books, and which I find exceptionally interesting. Some knowledge of the stories which are depicted does much to enrich my enjoyment of the paintings. Here there are eight scenes representing episodes from the tale of the origin of the Holy Cross.

August 7
In the ground floor [of the Museo Nationale (Bargello)] there is a room of 14th-century sculpture. The period of 1300 AD is in my opinion one of the greatest in history. The complete absence of petty cleverness or mere realism .. the concentration on symbolic expression, produce figures and heads which really excite me. Their proportion is naive and primitively beautiful, of a type closely related to other periods of sculpture: early Greek, Indian, Mexican. It is strange that whenever there is an unconscious work of such nature, part instinctive, part traditional, part child-like, devoid of petty ideals of human proportions, there invariably appears great sculpture.

August 8
Today, I have spent a whole hour completely enveloped in the wonderful world of Uccello's *Battle of San Romano* [...]

The work of Uccello (1397-1475) is so often wrongly condemned as a mere exercise of skill in the use of perspective. Certainly perspective was one of his main passions and probably his absorption in its science has enabled him to better use his great genius and decorative instinct.

I am convinced that Paolo Uccello is one of the greatest painters of all time [...] Here .. on a gigantic piece of wood is spread a miracle of work in paint. Not only is the bigness of the composition full of a unified moving force, but every little square inch, on close examination, can be found to be organised exactly to form a beautiful shape which fits perfectly into the whole, miraculously as individual molecules take their place in the formation of matter.

August 19, Arezzo

Piero della Francesca's *Scenes from the legend of the holy cross* (1452-66) .. is a great and satisfying composition [...] (It is interesting to note the obviously direct influence on the paintings of Puvis de Chevannes) .. [In *The victory of Constantine over Maxentius*] The confused army retreats into a mass of new plaster and to the right-hand edge. There is a peach-coloured banner with a green dragon, behind is a fine piece of turquoise sky surmounting a perfect example of typical Franciscan hillside .. an indistinct purple colour as if covered with a typical icing-sugary transparent snow with the familiar patches of grey-green shrubs and trees .. very beautiful .. I am greatly moved by this little piece. (It is interesting to note that this type of landscape with hills dotted with olive trees is absolutely typical of the Umbrian scene, particularly to be enjoyed around Arezzo and Assisi.)

From the ditch where the horse is struggling, there emerges a clear liquid stream, still and calm like a peaceful pool after rain, cool and quiet, edged with a few trees (Piero trees, real yet simple but truly wooden) away into a distance of hills just exactly like the river Arno outside Firenze, and painted with such natural tonal perspective in perfection of colour and light reminiscent of the perfect tones of Cézanne. Again I am reminded of the battle scenes of Uccello, particularly in the left-hand corner [...] How noble is the whole scene, how proudly the victors ride [...]

August 21, Assisi

This first evening is one of indescribable poetic intensity. The little hotel is a place only to be found in dreams. One enters it by the garden of white doves and cats and hanging greenness of vines. The little white tables are laid out all neat and clean .. we do not eat here, but in our little room high up, looking over the fine roofs, reminiscent in their construction of those in Switzerland. And like Switzerland also is the spiritual magnificence of the scene. As the sun sank, so did the atmosphere become more and more electric.

It is a mood which is not easily understandable by those who are not capable of experiencing it .. this which can only be described, for want of a better word, as the Poetic mood. In such a time as this glorious evening there is such a deep awareness of the magnitude of creation, of the true greatness of the little things created by God .. to look out of the window at the cobbled street with its clucking hens is to experience the miracle of death or birth .. the white hens in the dusk, scratching in the rubble, the colour of the stones all so alive and breathing, the sweet walls and the sounds from within them .. like beings themselves, the houses, their own hearts beating, their own organs moving, their inhabitants. And the colours of the rough tiles of the roofs, so indescribable in their infinite variety. There before my eyes is a scene which, were it to be truly described in words, would fill a million volumes. To clutch something which can express a small section of a stone wall, its colour and spirit, would even be impossible .. and such anguish fills me, that it cannot be fixed or described, I can but describe my own utter joy and complete misery .. two in one .. the sympathy of my soul. From out of my eyes was spread in fine threads, a spirit all around, and searching each thread till it found a minute particle of matter somewhere there before me [...]
[...] Who is this who is grumbling to me about poetry? This is the true spirit of all Art, the deepness of the poetic vision. Listen then to me, ye would-be artists; for first ye must become poets.

August 22

Of all churches, surely this [the Upper Church of the Chiesa di San Francesco] is the most moving and the most important perhaps in the history of Italian art. The cool spaciousness is a delight .. Never before have I seen such beauty of colour in a building: such a richness filling the whole space with deep rich brown, Indian red, emerald, pink and pale blue.

[...] Here [in the Transept and Choir] are the frescoes of Cimabue? very much faded into a rust, but for me still the most moving of paintings. There is a greatness here which can be found nowhere else. In the side of the transept under a wide arch is an *Ascension* .. like a grand oriental ascension of Buddha .. fine pastel colours as if done by a child on purple brown paper .. acidy green, yellow ochre, faint reds, deep browns. Above are the vaulted ceilings, patches fading and green in the starry blue like moonlit clouds.
[In the Lower Church] The interior is heavy and dark with the strangely sweet spirit like an incense. There is a width, but the low ceiling is arched round Romanesque to the floor .. like coming into a great mysterious cave in a mountain [...]
[...] Opposite the entrance is a chapel of St Catherine. In the paintings on the great arching walls there is an astonishing relation to Persian art. In each scene there are the animals reminiscent of Oriental illustrations ..
[...] To find Cimabue's *Virgin and child with four angels and St Francis* (1280) surrounded by Giottesque paintings .. I am amazed at its magnificence [...] how much more advanced was the mind of Cimabue than any of his followers. Giotto is certainly not a development from him; though great also, he is more truly of his own time. Cimabue, I feel, can really be called a 'modern' .. his conception, his breadth, both

are sympathetic with our own time.

This is a perfect lesson .. to see this piece surrounded by later works .. shining forth like a great window in the dimness.

August 26, Rome

This is a hotch-potch of a city, neither old nor modern [...] everything overlaboured with meaningless sentiment and baroque ornament. St Peters is an abomination .. the biggest of all abominations. All that is worth seeing is hidden away in dirty little neglected churches amongst slums .. marvellous mosaics.

September 8, *en route* to Pisa

Breakdown in the country .. sunset and moonset .. the old poetic stimulus like the nights on guard [during Davie's earlier war-time service in England] .. the urge to dance .. the creative urge in a suggestiveness towards nostalgic poetry .. the needs of the creative mind .. medium being only subservient to inspiration .. the fine awareness of the bigness of small things .. a little portion of a ditch .. grasshoppers' evening song .. the great divine movement from within bursting outwards in a manifestation to hand. How ignorant are the American fellow-travellers .. they are blind to all such beauty: talk, talk, talk: pride of war .. of killing: tales of destruction and brutality during the occupation of Italy. But how many can really appreciate the true soul-deep awareness of the poet .. poetry, the name which embraces all artistic feeling. So many fields of vine here .. black grapes close clustered ..

December 20, Venice

The last weeks have not been idle. I have produced some hundred monotypes. Through this wonderful medium I have discovered so much and so rapidly .. my work is becoming something very strange .. much in sympathy with modern music, particularly the Swiss, Honegger. I was so much moved by his music at the last concert we heard, I was shaken with violent sobbing .. Music is developing .. at least we are now able to discern a development in contemporary work .. the great innovation is in the intelligent use of 'unresolved' movements .. the great and true beauty of what was hitherto considered to be ugly and unsatisfying ..

[...] I am beginning to see. Paintings shall come with labour and appear one by one like strange broken wall surfaces that have suffered the marks of ages of rain and wind, pale blue and mauve with stains of dampness and fungoid parasites. So also shall be my works .. natural things grown upon canvas or board or wood, like multicoloured mossy patches on the forest floor.

January 27 [1949]

I was in a new church [Church dei Frari] today .. saw the *Ascension of the Virgin* by Titian.

How light a work is this! How lacking in depth of feeling! What religious power is expressed in such delicious little angels (more like cupids)? The Virgin is more like a society beauty, a little bored with life. The church itself is overburdened with horrid tombs but is impressive nevertheless, with a strange mystery. It was nearly dark when I entered. I felt a sympathy with the kind of painting I had just been doing. I realise that the so-called religious Art in churches is truly sacrilegious .. I feel that the 'modern' spirit in Art is much more suited to the expression of religious feeling.

February 5

I am up to the eyes in sparkling literature .. the illuminating writings of great artists we had not previously known much about .. [*On My Way* by Hans Arp and *Beyond Painting* by Max Ernst].

Why did we not come into contact before with such advanced ideas as those of the Dada movement which originated as far back as 1916? I am amazed to find in them a consolidation of and sympathy with my own previously dim and lonely strivings.

February 14, Antibes – Cannes

In discussing ideas of Art in a mixture of German, English, French and Italian, I find once again that young artists are thinking much the same as I, and, although isolated from one another by the unsympathetic environment of people in general, are developing in a common direction. The general aim is towards an art which is fundamentally opposed to conscious and systematic work, towards an Art freed from the props of individualism and mannerism of style, an unlogical Art against accepted human laws and values, but bound in its free rhythm and natural force by the true laws of natural form, the unknown laws which govern in such a mysterious way the elements of sky, sea, stones, jungles, stars and celestial spheres. Such an art cannot be called 'Abstract' .. the word really embraces such vague ideas as thought, space, time, love .. our Art, on the other hand, is truly con-crete as the flowers, the sky, the waves of the sea [...] The setting free of such inherent power and instinct within us is hampered most by consciousness: the con-sciousness which is the door that shuts. Our problem is to find a method of overcoming or 'hoodwinking' consciousness during creative work, that our growing powers may freely assert themselves through us [...] [...] I have thought much on the problem and have been convinced of certain things by a close analysis of my own works (those that remain for me as vital

expressions), and the true state of my mind during their execution. In every case I find that the work finally took place when my mind was in a state of confusion or despair or of semiconsciousness, usually after a period of more or less conscious struggle. In every case also, I have been incapable of seeing each work as I am now able to see it. I therefore believe that I have arrived at a philosophy of Art creation, although I am certain that in reality, the processes are actually infinite and involved, embracing many factors in mental and physical action beyond our capability of comprehension.

February 23, Barcelona

This morning we found the Cathedral .. truly the most wonderful church we have ever seen .. Catalan Gothic, 13th-15th centuries ..

[...] There is a beauty of proportion which I have never experienced before .. a pure spirit apart from mere religious sentiment .. How does this sympathy run in me from this Gothic Art work? Why do I find such a strong echo of my own painting desires come back to me when I see all this beauty? Why does it thrill me so much to follow with my brain the simple upward strong thrust of the columns up and up and branching flatly into the roof?

February 25

We found in this museum [Museo del Arte Cataluno] many treasures of Romanesque art, finer than anything of its kind we have seen. There are unique frescoes taken from old churches of the Pyrenees and wooden carvings and crucifixes of a marvellous beauty: paintings on wood, frontals from altars, 10th to 14th centuries, remarkably well preserved. Here there is the vital Art which comes from a simple people; no Art of famous individuals: an Art strong and curiously unified in style, an Art that is savage, almost like that of Africa and the modern expressionists .. sure and strong, yet wonderfully simple [...] A similarity also to Russian Ikons, particularly in colour .. Many pieces are painted on a solid ground giving a glowing quality to the liquid eggy tempera. A crimson of flames seems to dance in space.

March 5, Granada

A young gypsy boy dressed in rags, the torn sleeve of a dirty shirt hanging down inside his ragged coat, suddenly appeared beside me, looked up as if for inspiration into the sky, took a breath and began to sing. A strangely thrilling little song, probably extemporised at the moment, very Arabic in flavour .. a sad nostalgic song, not the song of the dancers, but the song of evening and peaceful contemplation. Such a passionate clear voice, such expression of genuine emotion, with that slight huskiness typical of the voice of a boy .. the hanging on a flattened fifth high up, delicately chosen, then falling in a coil of beautiful trills like waves on calm water, to finish in curious incomplete end of a minor third, starting again from a different note another phrase beginning in delicious variation, many notes ending with a fall at the expiration of breath very similar to a similar style in negro jazz. I find this music equally thrilling .. very passionate and creatively romantic.

March 6, The Alhambra

We fully expected to find something vulgarly superficial and over splendid. But instead of something sensational, we found quiet little gardens with delicate cool fountains amongst little white pavilions and arched ways with delicious views of the beautiful town far below. So delightful a place is this; surely a Heaven upon earth. I have never before felt such an atmosphere of quiet and absolute repose and peace. My whole being was immediately immersed in a sweet romantic spirit: an all-embracing gladness of love [...]

.. Everything is so simple and so modest and so delicate and so small, produced out of a Moorish philosophy of beauty and life, a philosophy of the simple things. And many red steps led us into successive smaller gardens each more charming than the last, all with delicious fountains and small trees ..

[...] The sunset was again miraculously beautiful over the mountains. Soon the lights were dancing in the city below.

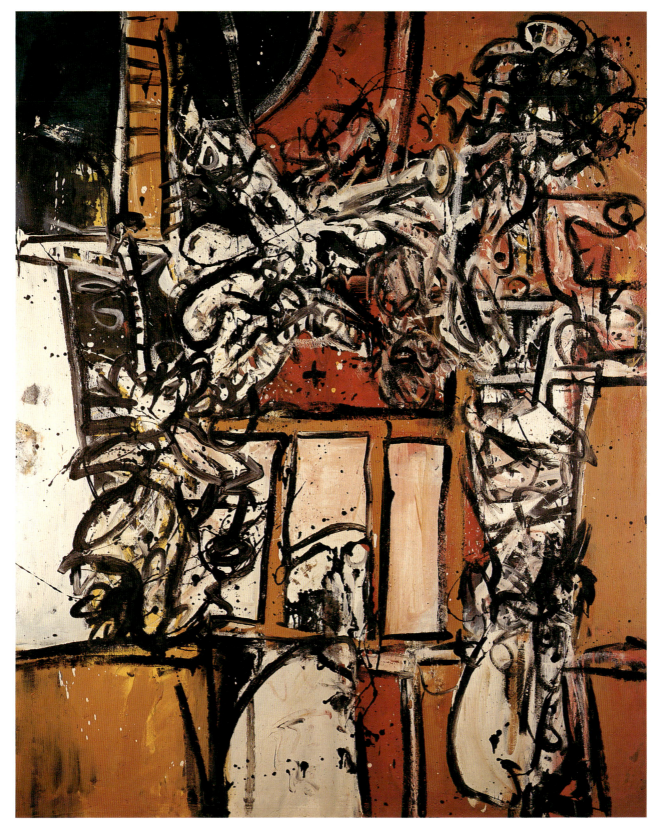

1 **Farmer's wife no.2** 1957 oil 213.4 × 172.8 (cat.58)

Note on plate captions
Asterisked works appear in the Brighton Festival exhibition
Alan Davie : The Quest for the Miraculous
Dimensions given in centimetres, height before width

'Listening to the music of heaven and earth': reflections on the art of Alan Davie[1]

Lynne Green

Alan Davie is an artist I have admired for a number of years – I inherited a book on his work from a friend long before I saw it 'in the flesh' or knew I would make art history my profession. Over the years I have encountered an individual work, or seen an exhibition, and have always been stopped in my tracks, always profoundly moved. There is no question that there is rich delight to be found here, but there is also disquiet, uncertainty, sometimes fear. This is not art for the faint-hearted: there is raw power in these teeming images.

Davie's art is firmly founded on the conundrum of being human in relation to *something other*. This is not the art of a man who believes in the triumph of rationalism. Davie is rather a modern magician, who deals in his creative process with the forces which animate our lives. The unconscious, yes, but also something beyond even that dark labyrinth – the collective, the universal, the transcendent.

I have in my hand a stack of colour photographs of Davie's work. I flick through them like the books we had as children which with rapid movement brought a line drawing to life – and I am presented with a 'moving film' of images, forms and symbols which reveal the rich language of our mythic mind. It is a record of one man's encounter with the exotic, the esoteric, the arcane vocabulary with which humanity has sought to interface with the transcendent. It is an encapsulation, a vivid and resonant statement of the inherent human need to reach out, to draw succour, reassurance and faith from the unseen forces which lie beyond our perceptual world.

Davie is a modest, gentle man who talks fluently and with apparent ease about the insights into *meaning* he has gained from his interest in other cultures, other times, but most of all from his *experience* of living and creating. I am immediately struck by how inter-related all this is, and by the seamlessness of the tapestry of impressions, thoughts, experiences and images presented as he talks. Yet the richness and the diversity of Alan Davie and the way he lives his life come together like a beam of focussed light in one thing – his painting. Of course, he is a jazz musician of professional standard, true he plays hours of classical piano music each day, and yes, he is an accomplished poet. There are, and have been, other absorbing activities, and passions too: making jewellery (for a living), gliding, sailing, gardening. The breadth of his accomplishments is astonishing. It is striking, too, that his abilities and passions span all his faculties – his sensual experience encompasses the extremes of physical effort and the subtle dexterity of ear, eye and hand. He is a man who lives with each of his senses alive and receptive, exploring and absorbing all that life offers. How many of us can claim the same alertness to possibility, to potential?

Painting, then, focusses, brings together this rich and diverse *experience* – but how? The act of painting is not easy for Davie; he talks of the painful enactment of the process out of which the work comes. There is a ritual of giving up, of relinquishing the intellectual, judgemental self as a necessary prelude to spontaneous intuitive creativity, in which an interplay of eye and hand, of the unconscious and the universal, is a single creative force.

*Stop this day and night with me and you shall possess
 the origin of all poems
You shall possess the good of the earth and sun …
 there are millions of suns left,
You shall no longer take things at second or third hand
 … nor look through the eyes of the dead … nor feed
 on the spectres in books,
You shall not look through my eyes either, nor take
 things from me,
You shall listen to all sides and filter them for
 yourself*
WALT WHITMAN, *Leaves of Grass*

Having attended Edinburgh College of Art from 1937 to 1940, Davie's years of war-time service were an interruption and a revelation. Posted to an anti-aircraft battery in the coastal country of South-east England, it was the first time he had lived close to nature. He made his own hut furniture and created a garden of wild flowers. He was not able to paint, but having discovered a copy of Walt Whitman's *Leaves of Grass* amongst rubbish under his bed, became a poet. Centred upon the sort of life Davie was actually experiencing at that time, Whitman's poetry was a revelation. Discovery of Eliot, Pound and Joyce

2 **Woman arranging flowers** 1945 oil 68.6 × 88.2 (cat.47)

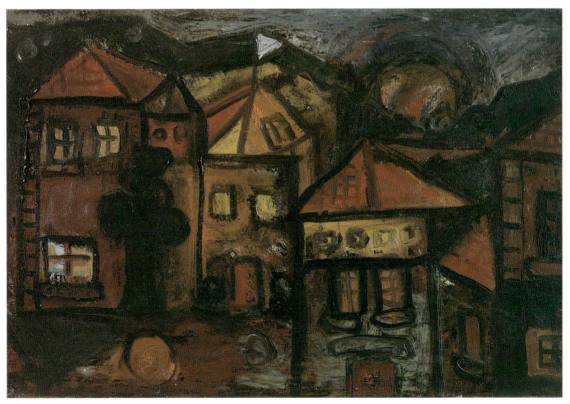

3 **Sunset** 1946 oil 61 × 91.5 (cat.48)

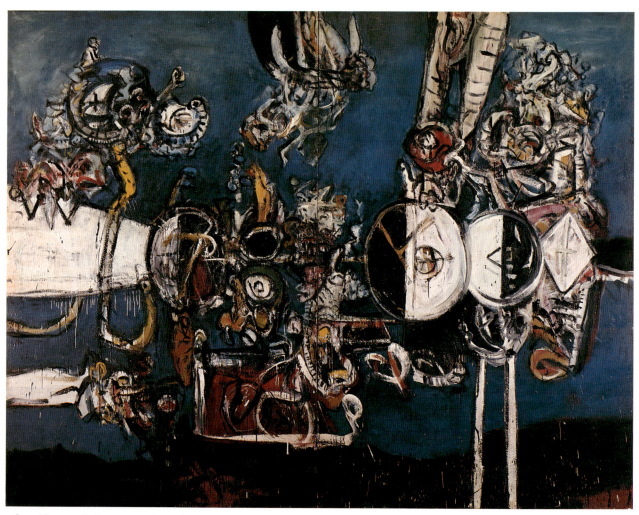

4 **Sacrifice** 1956 oil 244 × 320 (cat.57)

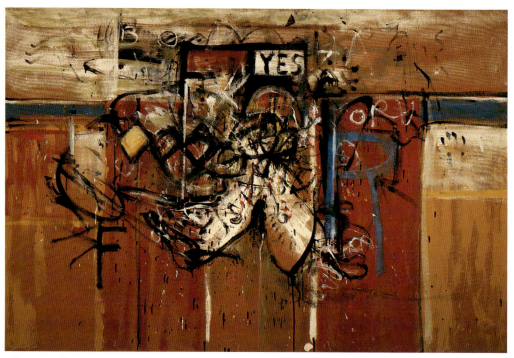

5 **Yes** 1955 oil 160 × 241.2 (cat.55)

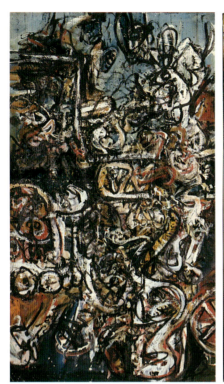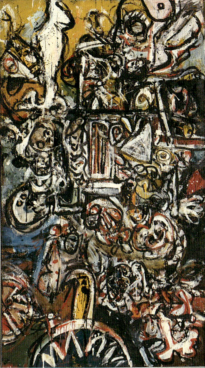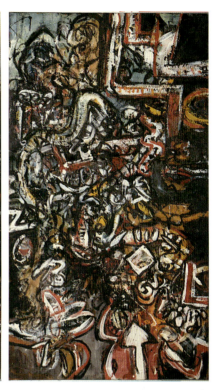

6 **Creation of man** 1957 oil 213.4 × 366 (cat.59)

followed, and through them, Oriental philosophy. All of this distracted Davie from painting.

After the War he married the potter Janet (Bili) Gaul and thanks to a scholarship travelled – to Paris, Switzerland, Venice. In Venice, his interest in being a painter was re-kindled. The Biennale di Venezia was showing work by Picasso, Moore, Chagall – it was colourful, exciting, alive. Peggy Guggenheim took him under her wing, bought paintings and introduced him to the work of the Americans Motherwell, Rothko and Pollock.

In the early years of his return to painting, Davie's work reads like an exploration, as if feeling his way towards an appropriate, a *personal* means of expression. There are echoes of European masters (Klee's structure in particular, the magic of Chagall, certain aspects of Picasso) as Davie allows the reverberation of his re-discovery of painting to subside, to assimilate. The *gesture* of the American painters, the liberty of 'free paint', become increasingly influential as the 1950s proceed. His work during this decade earned him the title 'action painter', with his work being seen as a European manifestation of the American Abstract Expressionism phenomenon. The label, while essentially misleading, is used to describe the work of a number of painters and sculptors who had in common a belief (however loosely held) that the purpose of art was to re-establish contact with the unconscious and our primordial source. With the example of archaic and primitive art in mind they sought to externalise the internal, to bring the events of the unconscious into the realm of the conscious. Their ideas and the liberating effect of their working process were enormously influential and for a time turned the tide of art's history firmly towards *expressionism* and away from representation.

Like many artists of the European avant-garde before them, the Americans developed an interest in psychology as a source of aid for the threatened individual. On the whole, Jung's theories of archetypes and the collective unconscious were more sympathetic to artists than Freud's theories, which were thought too

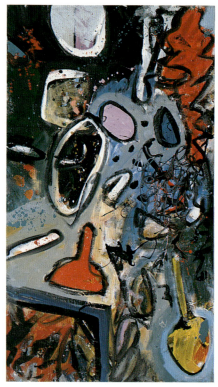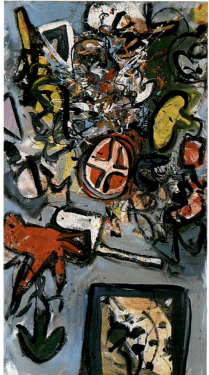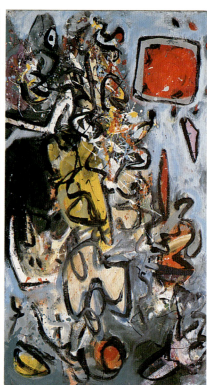

7 **The red dwarf** 1962 oil 213.4 × 366 (cat.64)

intellectual and too determined by Western European culture to be sufficiently universal. Jung's emphasis upon the accessibility of the unconscious, and upon the artist as the mouthpiece of its mytho-poetic character was particularly attractive. Searching for pictorial equivalents of universal experience artists were drawn to the theory of archetypal myth.

In America, the arrival of the emigré Surrealists had served to heighten the disaffection with established artistic expression and to bring into focus the possible alternatives. The Surrealists, with their emphasis on the instinctual and the archaic, employed the concept of universally meaningful forms buried in the subconscious, attempting to express them via the use of ancient myth, symbols and signs. They had also incorporated Freud's concept of 'free association' into their technique of psychic automatism, in which the spontaneous wandering of mind or hand was unchecked by reason or logic. Such unhampered creativity allowed the subconscious to release images buried within it. The stress of automatism upon *process* as central to creativity and pre-eminent over conception helped liberate Davie and his contemporaries from the constraints of conscious intention.

During the 1950s artists in both Europe and America equated freedom with gesture and the spontaneous mark-making of 'pure painting'. Many worked with

their canvases on the ground – so that they could pour paint and it would stay. Alan Davie's work from this period is urgent, full of energy and attack. Speed was seen as a mechanism for overcoming conscious decision, for unlocking the spontaneous intuitive image. At times there is a close affinity with the work of the Americans, particularly with that of Adolph Gottlieb and Jackson Pollock. The titles of Davie's paintings themselves invite comparison with Pollock – Davie: *Blood creation* (1952); *Domain of the serpent* (1951); *Woman bewitched by the moon nos 1 and 2* (1956). Pollock: *She wolf* (1943); *The moon cuts the circle* (1943); *Totem lesson 1* (1944).

The relationship is with Pollock's pre 'drip' paintings from the late 1930s and early 1940s, where archetypal imagery merges with calligraphic and gestural mark-making. There is the same use of totemic forms, at times discrete, but at others almost obscured within a matrix of sinuous, organic shapes, or by signs and symbols borrowed from native cultures. The work of both artists is informed by a knowledge of Surrealism and a desire to tap the unconscious and the collective.

The apparent liberation of 'action painting' went stale relatively quickly for Davie, who recognised, in painting no less than in the playing of free-form jazz, that this kind of freedom had its own limitations. Even Pollock, whom Davie came to know quite well, felt

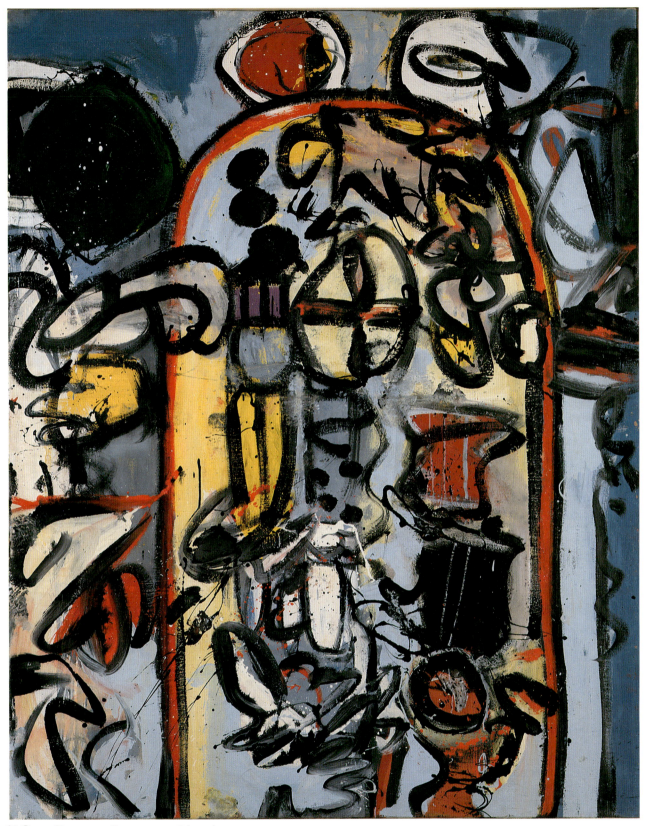

*8 **Crazy ikon** 1959 oil 213.4 × 172.8 (cat. 1)

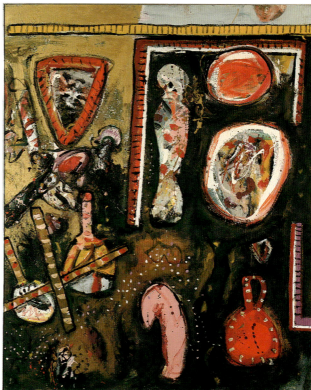

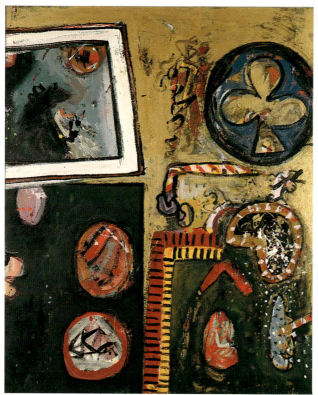

9 **New diptych for crystal gazers** 1963 oil 183 × 304.8 (cat.66)

towards the end of his life that nothing more could be said by this means. Davie discovered in painting and in music that it was, paradoxically, through structure and the discipline of form that inventive freedom lay.

Painting has taught me much, mainly that it is impossible to paint a picture and that if a picture is to be, it must happen in spite of me rather than because of me ...
ALAN DAVIE 1959[2]

Davie's discovery of Zen strengthened his own recognition of his need for discipline as the means of overcoming the constraints of the conscious mind, its preconceptions and judgements. The discipline and practice of Zen in the arts of archery, flower arranging and the tea ceremony are ritual means to spiritual ends. Through training, the conscious mind is brought into contact with ultimate reality. The 'rules' and structured practice of the form attune the mind to a new level of awareness, but technical knowledge is not enough. To be a master one must transcend technique, the art becoming artless, growing out of the one-ness of the Buddha-mind. In Zen there is discipline and

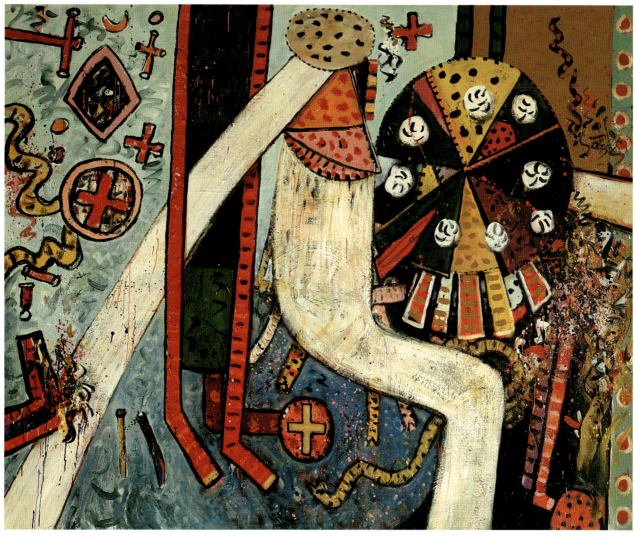

10 **Improvisations on a Chagall theme no.4** 1967 oil 172.8 × 213.4 (cat.68)

'waiting': in the latter, the former is given up and the archer/artist ceases to aim. The dialectic of opposites inherent in the human mind is relinquished in the release of the self–object division. In the end, the archer, the perfecting of skill, and the target are a single reality.

Zen advocates and teaches the greatest economy of expression. In attempting to throw light upon Alan Davie's lyrical and magical ink drawings I can do no better than to quote Shunryu Suzuki's description of the Zen way of calligraphy, which is 'to write in a most straightforward, simple way as if you were a beginner, not trying to make something skilful or beautiful, but simply writing with full attention as if you were discovering what you were writing for the first time, then your full nature will be in your writing'.[3]

Zen is concerned with regaining the childlike, un-self-conscious mind which has its root in our subconscious. Zen-mind is Beginner's-mind, limitless, 'empty, free of the habits of the expert, ready to accept, to doubt and to be open to all possibilities. It is the kind of mind which can see things as they are, which step by step and in a flash can realize the original nature of everything.'[4] All of this 'rang a bell' for Davie. He recognised intuitively that this approach to deeper levels of reality was close to his own intention.

Zen teaches that the deeper or unconscious mind (which I would describe as the *temenos*, the antechamber to the wholeness and unity of ultimate reality) needs repetition, ostensibly irrational logic and poetry in order to know itself. By repetition (discipline and practice) the conscious self is left behind; through such logic and poetry the unconscious self is expressed, and through expression is known.

Zen statements and explanations often appear paradoxical, contradictory, even absurd. This is

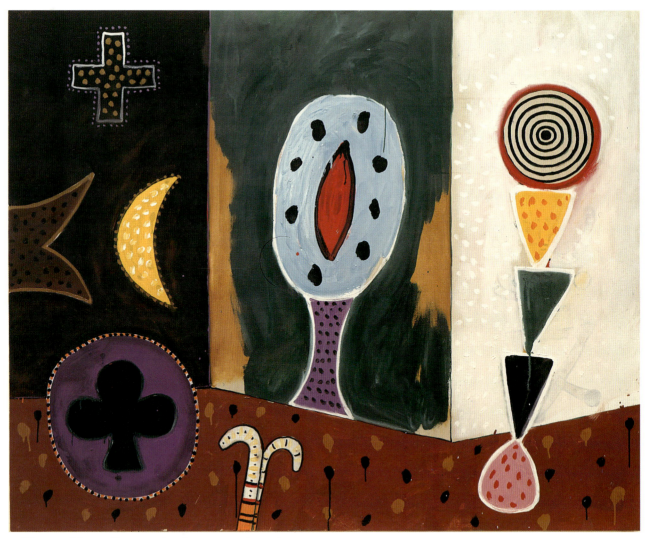

11 **Moon maiden walls no.2** 1970 oil 122 × 152.4 (cat.71)

because words, language, cannot express the deepest truths of Zen. They are, rather, to be *experienced* in the innermost self. The emphasis is upon revelation through spiritual insight, what is termed the 'foundation experience'. Around this Zen constructs its verbal and conceptual scaffold (its 'explanations' and 'philosophy'). But we are mistaken if we think this is the truth. While a means of reaching the innermost reality, it is 'an elaboration and artificiality [and] we lose its whole significance when it is taken for final reality'.[5]

In the same way, we must *experience* the art of Alan Davie in our innermost selves. If we take the *surface* of the paintings, the individual symbols and forms, and their relation one to another as the final significance – we miss the point.

In the midst of life there is what Zen calls the *fact of living*. This is a truth which lives at the core of our being. It concerns our relation to the central mystery

of existence, and it has been expressed through the agency of art since our human beginnings. Davie's eye is open to this greatest of mysteries as it is daily and hourly revealed. His insight is into the very nature of life – its implicit order and wholeness. In the elaboration of particulars, as he explores and articulates the manifestations of mankind's mythic mind, he intuitively grasps the whole.

For Davie, art is *not* concerned with self-expression but rather with 'the evocation of the inexpressible',[6] the universal, beyond the individual self. His practice demands the negation of the conscious self in order to unlock the teeming world of the universally-attuned unconscious. Believing himself to be working as artists in prehistoric and traditional societies have always done, Davie communicates with the collective. His experience of painting is almost religious and is certainly mystical. He describes a process in which he is aware of forces external to himself trying to work

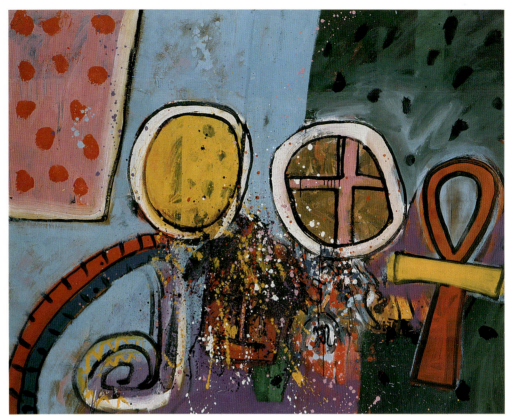

12 **Wheels for the sweet life** 1965 oil 122 × 152.4 (cat.67)

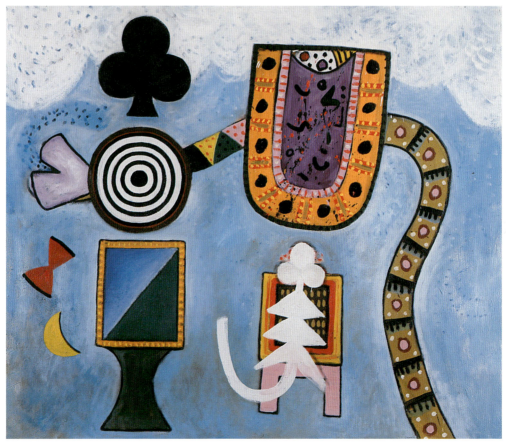

*13 **Serpent swallows the fairy tree no.2** 1971 oil 152.4 × 183 (cat.4)

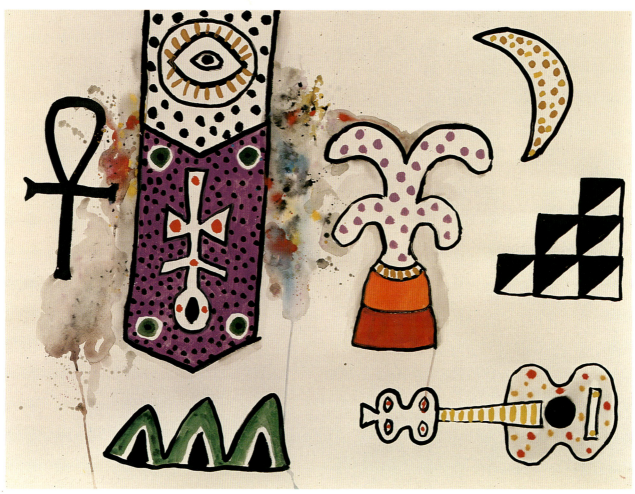

14 **Eye of life no.1** 1970 gouache 55.8 × 76.2 (cat.108)

through him. Often it is a struggle to let them out, for only by getting rid of the self can this transformational, this transcendent process begin. He has also described this process as assuming the 'mask' of the painting. Like the tribesman who, wearing an ancestral or spirit mask, *becomes* that mythic personage, so as he paints does Davie assume the spirit (the mask) of the painting. The language of this inner, collectively-attuned self is symbol and myth, expressed with a logic of its own, and in a way that is poetic.

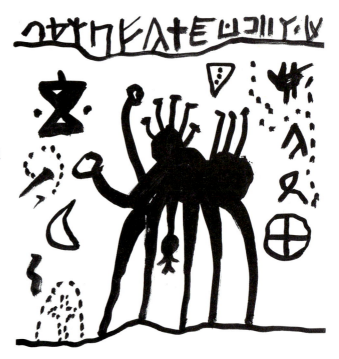

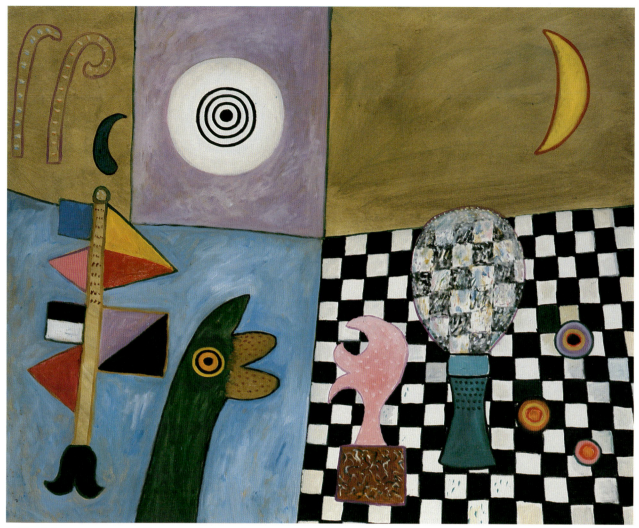

15 **Magic lamp no.27** 1974 oil 152.4 × 183 (cat.75)

Poetry visually expressed speaks its own language
JOAN MIRO[7]

In an essay entitled 'The poetry and prose of painting'
Herbert Read employs the analogy of the poet's
'charged and electric' use of words for emotional effect,
words which are, moreover, full of infinite subtleties of
meaning and secondary aspects.[8] The poet may also use
words for their own sake, independent of their logical
meaning, because they have an 'inexplicable or magical
effect'. What Read says of words is as true of particular
forms, signs, symbols and colours. His description of
the poetic method might well be an elaboration of Alan
Davie's expressive means. Having divided painting into
'prose' and 'poetry', Read goes on to say of the poet-
painter that he is 'interested in using his colours for
their own sake, and for the sake of the moods they can
evoke in association with the things he depicts'. Read

is actually moving towards a description (and an
apology) for total abstraction, but his words are
pertinent to the work of Davie, and are further support,
if such were needed, for placing this artist firmly in the
poetic camp.

In poetry (indeed, in language generally) rhythm,
emphasis and pauses hold thoughts together, give
words deeper meaning, heighten significance. Davie's
pictorial language, constructed of signs, symbols and
forms, functions in a similar way.

37

Canvas Man

I dive below the surface,
Fly above the surface,
Stride to mark the surface
But I have given up
Trying to become the surface
Because now I realise
There is no surface.

© *1992 Philip Ward*
loosely based on *Night improvisation no.7* (pl.16)

The Tip of The Tongue

The tongue of the painter falls silent:
it concentrates, poised like a humming-bird's,
touching neither teeth nor palate
neither exhalation nor inhalation
it hovers
without touching the back of the mouth
in the power of encircling galaxies
it neither gives nor receives
neither debates in vibration
nor meditates in the no-mind

But perseveres like a drugged glider
in the shimmering winds
without questions to ask or to answer
the tongue of the painter at seventy-two
begins to listen

© *1992 Philip Ward*
loosely based on *Zen poem no.7* (pl.17)

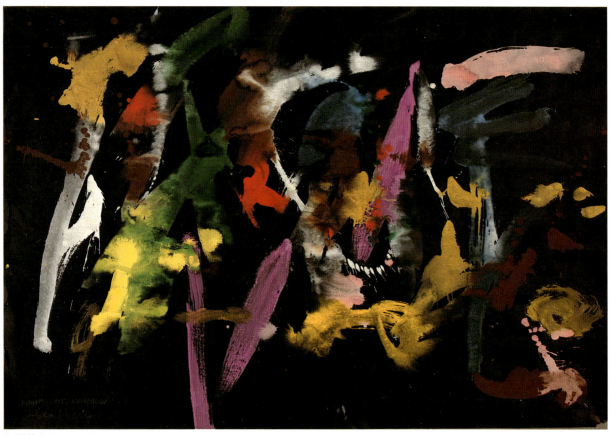

*16 **Night improvisation no.7** 1975 gouache 52 × 77.5 (cat.14)

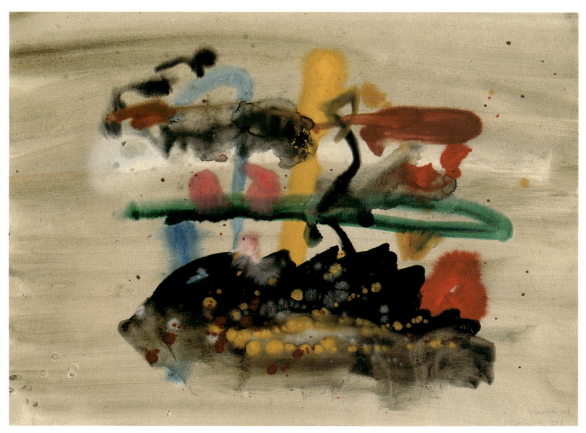

*17 **Zen poem no.7** 1977 gouache 59.7 × 84 (cat.24)

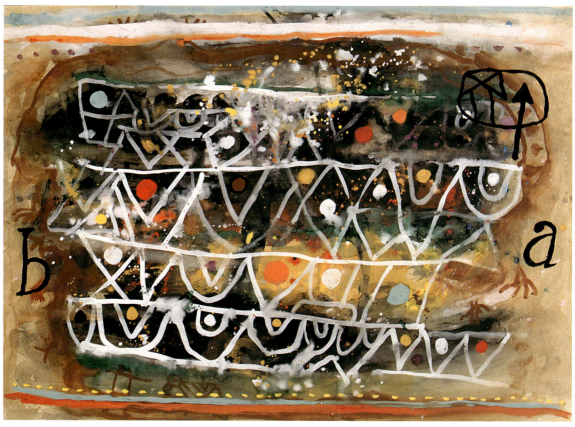

*18 **Homage to the Caribs no.20** 1976 gouache 59.7 × 84 (cat.18)

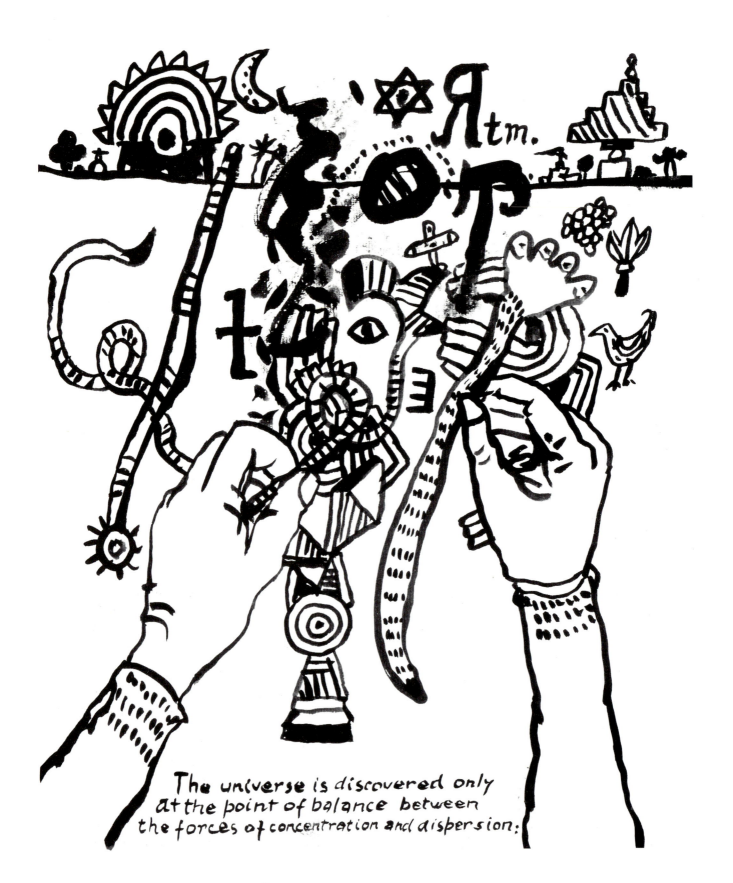

The universe is discovered only at the point of balance between the forces of concentration and dispersion:

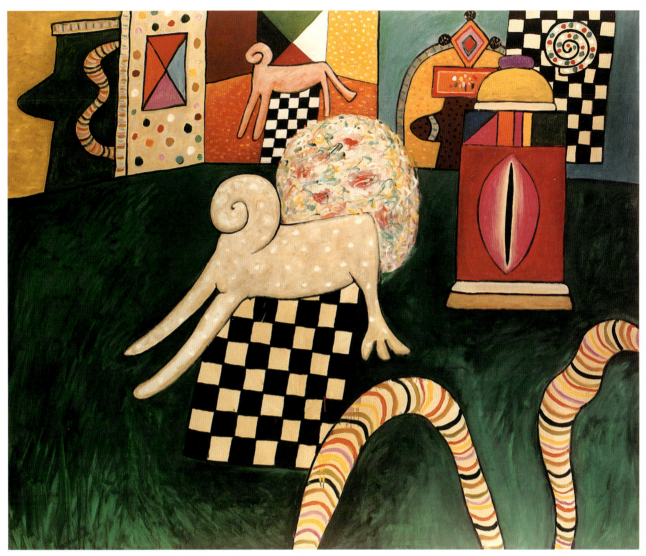

19 **The studio no.28** 1975 oil 152.4 × 183 (cat.76)

In the symbol, the particular represents the general, not *as a dream,* not *as a shadow, but as a living and momentary revelation of the inscrutable*
GOETHE[9]

The capacity of Davie's work to so profoundly move us springs from his acute awareness of the symbolic potential of form. Human beings have an innate propensity for transforming objects and forms into symbols, thus endowing them with psychological importance and power – often with enduring significance. It is clear that anything and everything can assume symbolic significance, whether natural or man-made. This is true also of abstract form – the square, the circle, the triangle and so on. From a vocabulary of individual symbols a language as complex and full of nuance as the written or spoken word can be constructed. The symbolic use of geometric forms to convey often quite complex concepts and ideas began long before the ancient Greeks used geometric diagrams to elaborate philosophical theory. The profusion of geometric symbols which appear in prehistoric cave painting would have conveyed to their makers as much meaning or 'content' as the depiction of bison and gazelle with which they were juxtaposed. By the Medieval period, diagrams or 'schema' were growing more and more sophisticated, becoming in manuscripts as important as the written word (or in some cases more important), given their capacity to express ideas concisely. Their message was, moreover, incorporated in carvings, wall paintings, stained glass and floor tiles. Recent research

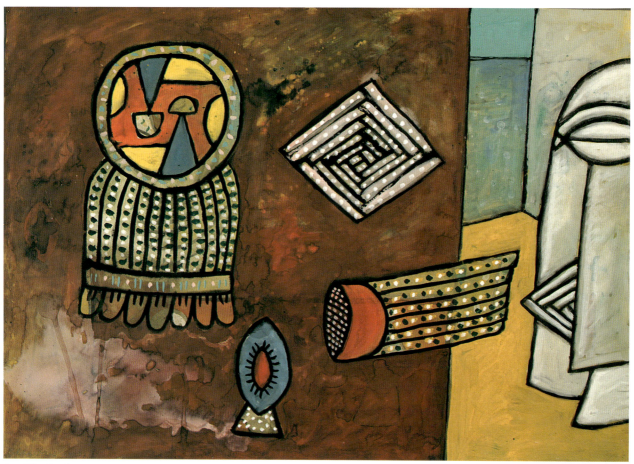

*20 **Magic picture no.43** 1977 gouache 59.7 × 84 (cat.22)

has revealed the complex cosmological significance of the great sanctuary pavement in Westminster Abbey.[10]

What is of relevance to the work of Alan Davie is that as with other symbolic use of form, geometric pattern does not illustrate ideas literally, but embodies them in meaningful relationships created between individual elements. The intention behind the pavement at Westminster was that the schema should enable the observer to reflect and meditate upon the theological or moral premise it symbolised. It should draw the observer in, and having done so, not dictate interpretation but encourage meditative participation in the revelation of meaning.

This, I believe, is the means by which the art of Alan Davie offers us the possibility of participating in the sacramental mystique of our world. There is no prescribed, no single interpretation of a work by Davie. Even the titles of individual works provide no more than clues. Certainly there is a vocabulary to be learnt – the symbols adopted, absorbed from other cultures *do* have specific (or several specific) connotations, both in their original context, and for our culture today.

Particular forms which recur clearly have special import for Davie himself. To pursue the origins of the individual elements too far, however, is an art historical conceit, and while intellectually interesting, the process is a distraction, and ultimately unnecessary to the resonance of the work. Davie paints because he must. The rest is up to us – and much is asked of us. It is suggested, however subtly, that we too need to suspend our intellectual analytical selves, and allow our non-conscious, unstructured self to hold sway. You and I are no different from Davie in that our mytho-poetic selves are capable of emergence and of participation in our lives. Davie's paintings and drawings are 'doors' to another, expanded level of perception, where the unexpected meet, and the seemingly unrelated have relationship.

The power of his art to draw us in, to initiate dialogue with our intuitive selves, lies in Davie's grasp of the fundamental *modus operandi* of the human psyche. In *Icon and Idea*[11] Herbert Read argues that in human consciousness ideas are secondary to images, that in the contemplation of the latter, the former emerge. 'We manipulate ideas by logic or scientific

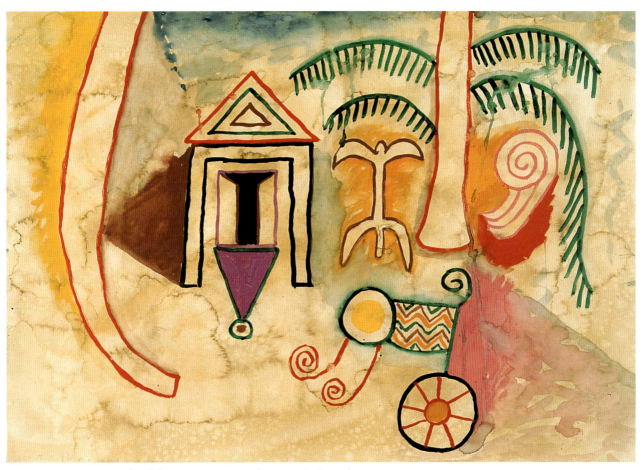

*21 **Homage to the earth spirits no.50** 1980 gouache 59.7 × 84 (cat.27)

method, but we come to them in the contemplation of images' – simply put, we think in pictures first. It is a startling proposition, which if taken to its logical conclusion could stand the received history of our intellectual development on its head : it would also do much to re-establish art at the centre of human experience! Whether or not we agree with Read's interpretation of consciousness, the sequence or process he describes is certainly what takes place in our contemplation of art. The work of Alan Davie exemplifies this relationship of work to viewer. His images reward contemplation. However arcane, they strike a chord in us, encourage associations (personal *and* cultural) and invite dialogue with our innermost selves.

The description of symbolism by the Hindu philosopher Ananda K. Coomaraswamy as 'an art of thinking in images'[12] is particularly pertinent in the light of Read's belief in the image as the first language of consciousness. We are surrounded by symbols and signs, they proliferate in our daily lives and we constantly take part in the process of appropriation

which imbues a given object with significance beyond its original function or meaning.

In our translation of *experience* into any medium we use signs which stand for, represent or signify that experience. The constructed sign, once independent of that experience, is open to interpretation and can become mysterious to others. Davie has a fascination with maps – the pictorial and symbolic translation of the experience of landscape. They look, feel and smell nothing like the signified, but we have learnt their symbolic imagery and can extrapolate their meaning into our own experience.

In recent years, Davie, who is drawn to the conjunction of text and image in alchemical treatises and illuminated manuscripts, has increasingly introduced words, sentences and even extensive paragraphs into his work. On one level they offer elaboration, even explanation, but essentially they function at the same level as the other signs and symbols he employs to express the magical and the mysterious. Often individual words or passages (many of which are not in English) are split as they 'pour' into

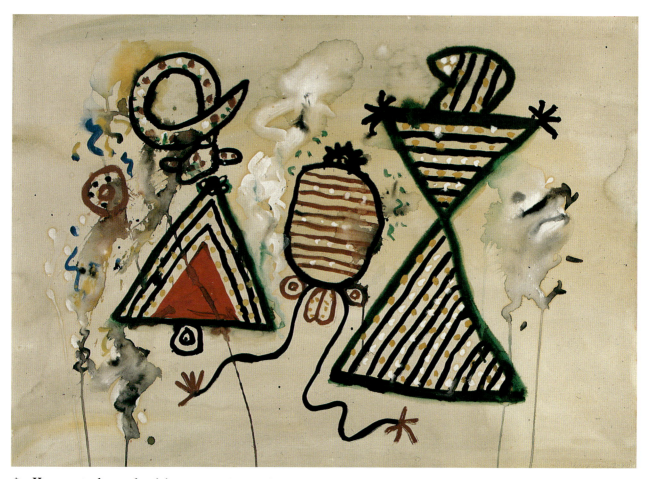

*22 **Homage to the earth spirits no.31A** 1980 gouache 59.7 × 84 (cat.26)

a space between other forms or spread across the canvas, accommodating the boundaries of other signs as they go. It is quite extraordinary how the unconventional division of words suddenly makes even a known language momentarily impenetrable, transforming it into something strange, tantalising and mysterious.

While the symbolic use of man-made and natural objects remains an important aspect of communication, in the West the endowment of specific forms with meaning has become largely a device for marketing. The capacity of form to convey and carry complex meaning, and to act as a meditative point of entry into deeper levels of reality is largely ignored, or dismissed as a device of superstition. This rejection of a fundamental human device for the embodiment of meaning is comparatively recent, an element in the triumph of rationalism in the nineteenth century.

The serious re-evaluation, in this century, of primitive societies and contemporary traditional cultures, together with the discoveries of psychoanalysis, has led, at the level of research, to a recognition that the endowment of images with meaning is essential to the well-being of both the individual and society. Only now, and largely via the popularisation of anthropology and psychology in New Age writing, is there a growing general awareness of this fundamental truth. It is clear, however, that an understanding of the essential role symbolic form can play in the transmission of meaning, and in accessing underlying reality, has long informed Davie's work.

In November 1969 a small but significant exhibition took place at the Gimpel Fils Gallery in London. Entitled *Magic in Art : Paintings by Alan Davie, Primitive Sculpture* it juxtaposed, with equal status and without comment, the work of a contemporary painter with objects from both prehistoric and traditional native cultures. In the slim catalogue an Agni tribal fetish figure and a dance mask of the Baule people are reproduced opposite paintings with titles like *Turtles love charm*, *Myth of the snake birds*, and *Magician with snake fetish* (all from 1967). If unfamiliar with the art of Alan Davie, one would have been forgiven for assuming that the works on canvas and the carvings had

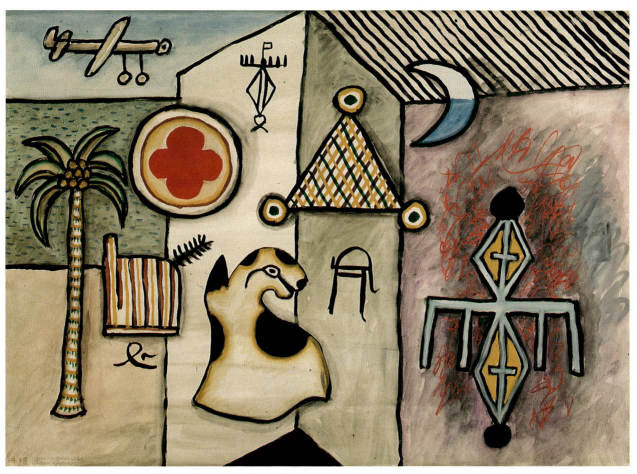

*23 **Yoga structures no.42** 1978 gouache 59.7 × 84 (cat.25)

the same origin. Although incorrect in regard to time and culture, fundamentally one would have been right. In creating and presenting such an exhibition, kinship between Davie and prehistoric and tribal artists was implicitly stated, and parallels and connections invoked.[13]

Without the inspiration of art from native and ancient peoples, the history of Western painting and sculpture since the latter part of the nineteenth century would have been immeasurably different, and arguably greatly impoverished. Many key figures in the development of art this century openly acknowledge their debt to what is generically termed 'primitive' art. Very many of these artists, central to the liberation of art from traditional constraints, collected examples of such art (as does Davie himself). Few artists have, however, exhibited their own work alongside these objects, whose genesis lies in ritual and the physical embodiment of myth.

Implicit in the *Magic in Art* exhibition is the acceptance of connection, of relationship. However diverse its formal manifestation, 'magic' in art is a constant which can unite artistic intention across millenia, continents and beliefs. The (Concise Oxford) dictionary definition of the word 'magic' has difficulty in deciding whether it is to be dismissed out of hand as the 'pretended art of influencing [the] course of events by occult control ...' or grudgingly admitted as referring to 'inexplicable or remarkable influence producing surprising results'. Referred to the word's root in *magus* ('member of an ancient Persian priestly cast; sorcerer') we are suddenly confronted by '*the (three) Magi*, the wise men from the East who brought offerings to the infant Christ'. So, magicians are not to be so lightly dismissed as perpetuators of superstition and ignorance. Pursuing this a little further (via the Shorter Oxford): 'wise: having or exercising sound judgement or discernment ... sage ... skilled; expert ... having knowledge; learned. In one's right mind ... sane'. Magic, then, is to do with skill, expertise, knowledge and *wisdom*! But this is not knowledge or wisdom in the intellectual sense, for magic is concerned with the conjuring of the unknowable, and magic, for Davie, 'is the outcome of art'.[14]

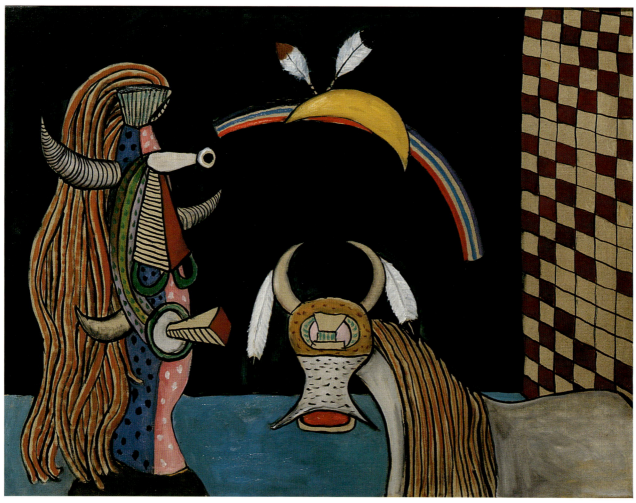

24 **Study for a figure mask no.24** 1977 oil 78.4 × 101.6 (cat.79)

Of course, the 'wise man' is a figure which has haunted the history of mankind from the first.

In any living tradition there must always be cultural exemplars who reflect a condition of primordiality which acts as a link between the natural and supernatural worlds. Such men (and occasionally women) possess certain qualities of behaviour and, more properly, a presence that others may recognise as being distinctively different. Among indigenous cultures such as Aborigines or American Indians these cultural exemplars are men who have undergone a ritual initiation that sets them apart from other members of their tribe … In the context of Aboriginal society the making of a *Karadji*, or clever man, is a vocation like any other spiritual discipline; few men are called to it and even fewer survive the psychic terrors that are so often inherent in its attainment.[15]

In all its cultural manifestations humanity needs individuals who fulfil this role. In prehistory and for many societies today it is in the priest-shaman that this need is personified. Shamanism is a universal mode with its essential themes strikingly similar across cultures. Recognising the transcendent in the everyday, shamanism establishes a link between the sacred and the profane worlds. The role of the individual shaman is to interface with the unknown – and through ritual and symbolism, render it comprehensible and applicable to daily life.

The greatest anxiety of mankind throughout its history has been to comprehend the hidden forces which animate nature, society and the individual. Recognition of these forces, and speculation as to their nature, are the genesis of all manifestations of the religious impulse. In traditional societies religion is still not a distinct activity : it informs and gives meaning and coherence to every aspect of life. As magician, healer, storyteller, *artist*, the shaman stands between his/her tribe and the powers which lie beyond the outward visible world. The means by which these powers are approached, negotiated with, even controlled are the shaman's alone. Via trance and ecstacy the shaman penetrates visionary realms, and by means of the magical journey links mankind with the cosmos. The shaman, who translates or rather enacts his/her

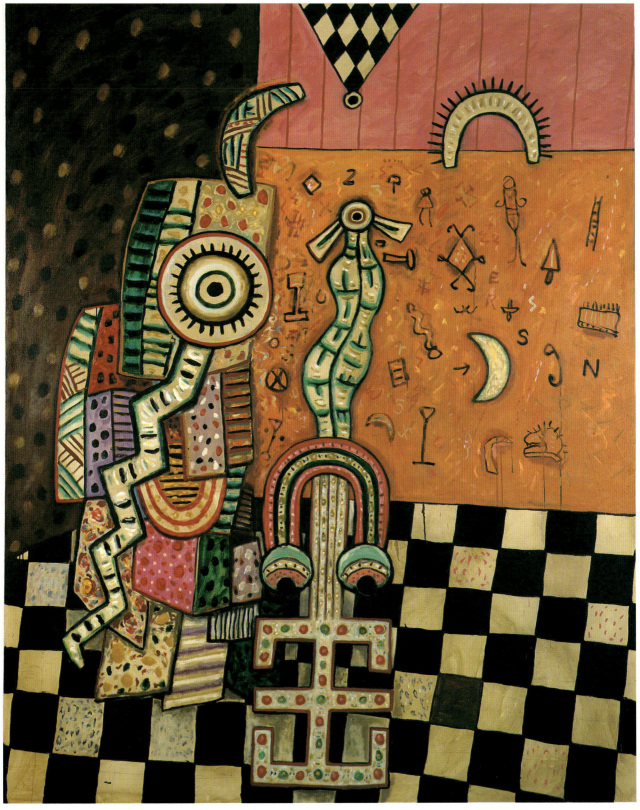

25 **Study for an Elizabethan spirit no.9** 1982 oil 213.4 × 172.8 (cat.84)

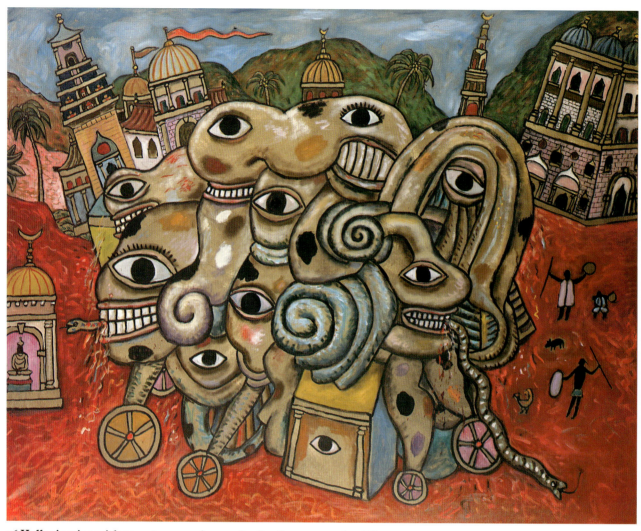

26 **Hallucination with monster on red ground** 1984 oil 122 × 152.4 (cat.86)

experience in many media – song, dance, carved and painted forms – is the archetype of all artists. Indeed, the identification of the shamanic and artistic roles once was, and for many cultures still is, total. The visual embodiment of the experience of the transcendent is a sacred act. In cultures as diverse as Native American or Tibetan Buddhist, the making of images is both the means of establishing dialogue with the ineffable, and the vehicle for making it manifest. Alan Davie clearly works within this archetypal tradition of the artist-shaman. I can think of no more illuminating description of his working practice than to relate it to the act of transcendence which lies at the core of shamanism.

Michael Tucker has written extensively and revealingly about the central importance of the shamanic consciousness in twentieth-century artistic creativity, and in so doing demands a re-interpretation of the relation of art to the sacred and divine.[16] It is clear that artists of this century, in a desire to return to the root of creativity, have increasingly identified themselves (consciously or not) with the essentially sacramental vision of the shaman. The experience of the sacred (of the transcendent) once lay at the core of all human activity. The artist-shaman was and still is the mediator and translator of that experience. I have always thought of the artist as a 'representative' human being, an explorer working (as does the scientist) at the very edge of understanding and knowledge. Like all explorers, the artist brings back a record of his/her journey. The path is often dangerous and fraught with difficulty, but what the artist's activity brings into consciousness is of profound significance, and is capable of enriching our individual lives.

In the writings of Joseph Campbell the shaman figure takes on the mantle of the 'hero', with the description of the heroic task closely akin to the shamanic. Both are figures who *on our behalf* venture

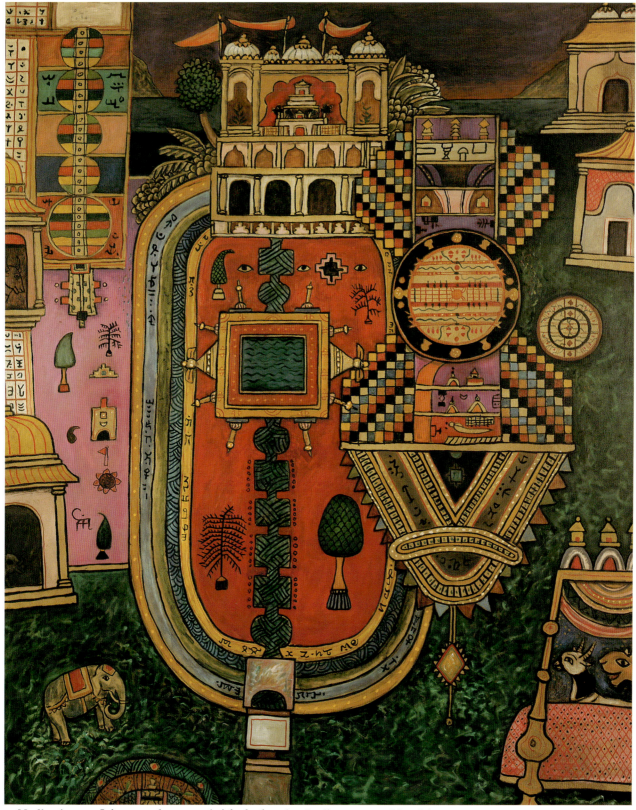

27 Meditations on Jain cosmology no.2 (with elephant) 1984 oil 213.4 × 172.8 (cat.87)

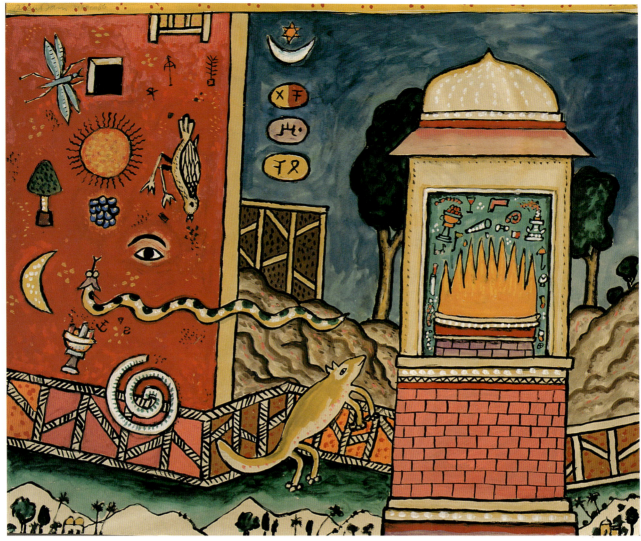

*28 **Mystical landscape no.17** 1986 gouache 59.7 × 73 (cat.31)

into the unknown. The hero's task is to retreat from 'this world of secondary effects to the causal zone of the psyche ... and to break through to the undistorted direct experience and assimilation of what C. G. Jung has called "the archetypal images"'.[17] What Campbell says of the hero figure is as pertinent to an under-standing of Alan Davie's creative means as is the parallel with the shaman : the hero (man or woman) is

able to battle past his personal and local historical limitations to the generally valid, normally human forms. Such a one's visions, ideas and inspirations come pristine from the primary springs of human life and thought. Hence they are eloquent, not of the present disintegrating society and psyche, but of the unquenched source through which society is reborn. The hero has died as a modern man, but as eternal man – perfected, unspecific, universal – he has been reborn. His second solemn task and deed therefore (... as all the mythologies of mankind indicate) is to return thence to us,

transfigured, and teach the lesson he has learned of life renewed.[18]

This statement encapsulates the conviction held by many artists of this century and epitomised in the work of Alan Davie.

There is no doubt in my mind that Alan Davie's is a 'sacramental vision', expressed through symbol and myth (which is the vocabulary of the transcendent). Such a vision is able to see, in the words of Suzi Gablik 'the divine in the human, the infinite in the finite, the spiritual in the material'.[19] If one has any doubts about the links between Davie's practice and his ancient predecessors who painted in deep, often inaccessible caves, one has only to consider *The high priestess and the magician* (1979-87) painted in the interior 'cave' of Niki de Saint Phalle's sculptural head.[20] Even in reproduction it is a work of great distinction and power

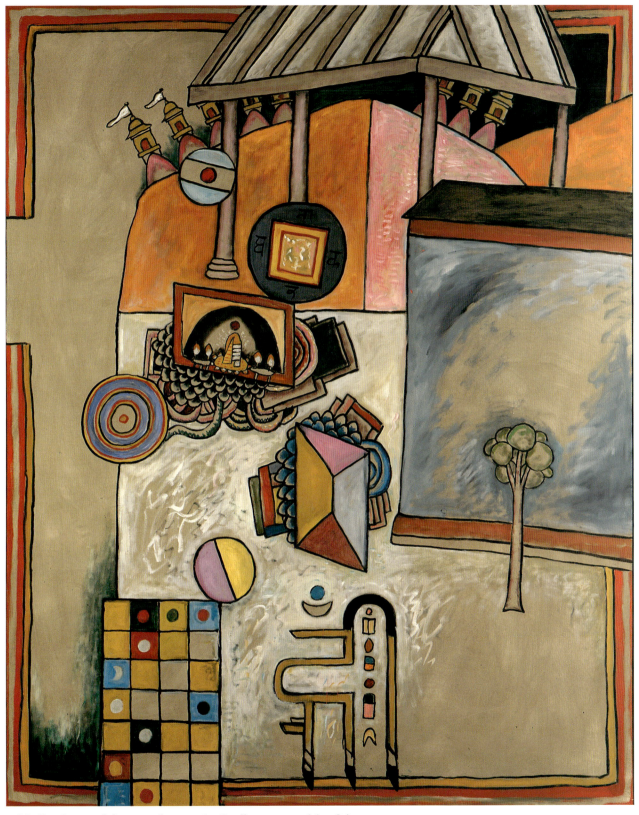

29 **Meditations on Jain cosmology no.6** 1985 oil 213.4 × 172.8 (cat.89)

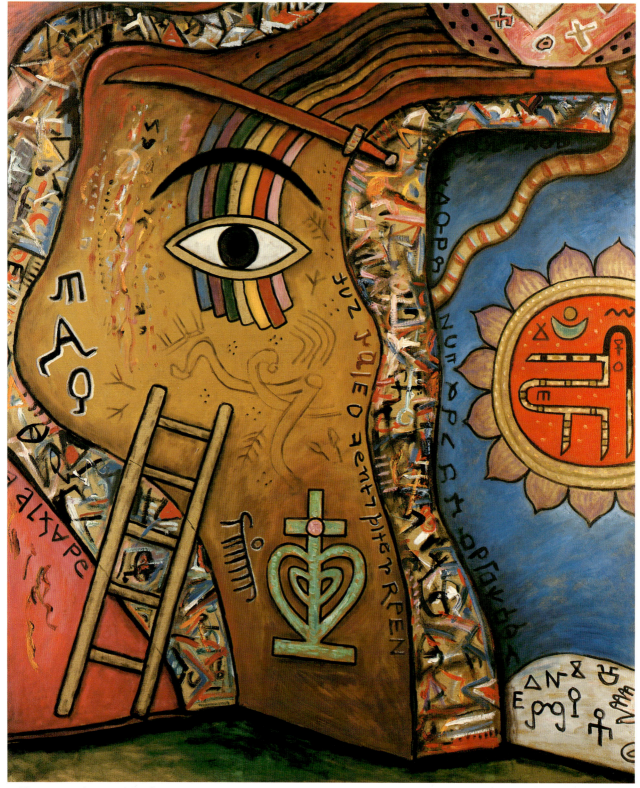

30 **Il mago study no.3** 1987 oil 183 × 152.4 (cat.92)

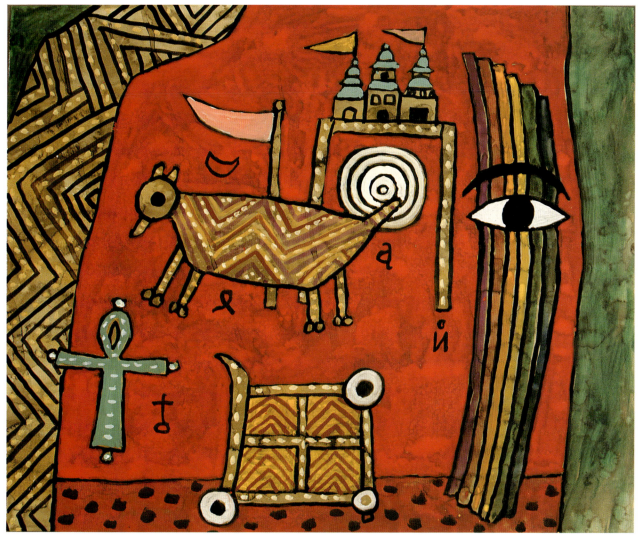

*31 **Il mago study no.3**G 1988 gouache 59.7 × 71.7 (cat.34)

which acts as a beacon to the continuity of the artist-shaman role.

The shaman's role is both sacred and perilous – he is known as the one 'doomed to inspiration'. Alan Davie has written of the 'struggle, the joy and the despair' that go into his work (but which are seldom apparent). For him the value of a work lies in its ability to 'convey something which transcends material'.[21] In order to achieve this level of intimation, a fundamental shift in his consciousness is required (the shamanic trance or ecstasy). What Davie refers to as the 'creative moment', when the transcendence of the self is achieved, is the magical transmutation of the shaman.

It is clear that for Alan Davie intuition is the key which unlocks his 'magical creative inner force'.[22] We all experience the intervention of intuition in our lives, 'knowing' without conscious intellectual knowledge. Most often we dismiss this inexplicable phenomenon as coincidence or chance. All cultures in some degree

acknowledge intuition, pre-cognition, second-sight, call it what you will. In native cultures it is an intimation of the transcendent, of the sacramental in the commonplace world. For these cultures, intuition is the light of revelation, the beam of recognition and understanding which penetrates the dark clouds of reason which hover between ourselves and the ineffable.

Davie's struggle to suspend critical judgement, preference, choice, decision is at times overwhelming. From the ecstacy and revelation of painting he can plunge into the depths of uncertainty and despair. Any artist who works on the edge of what is known and who ventures out into the visionary realm takes an enormous risk. Like the psychic terrors encountered by the shaman, doubts and uncertainty can prove too much to bear. It is the dark side of wonder and joy. At times the darkness has led Davie to destroy work, which in retrospect he found to have been valid. Yet

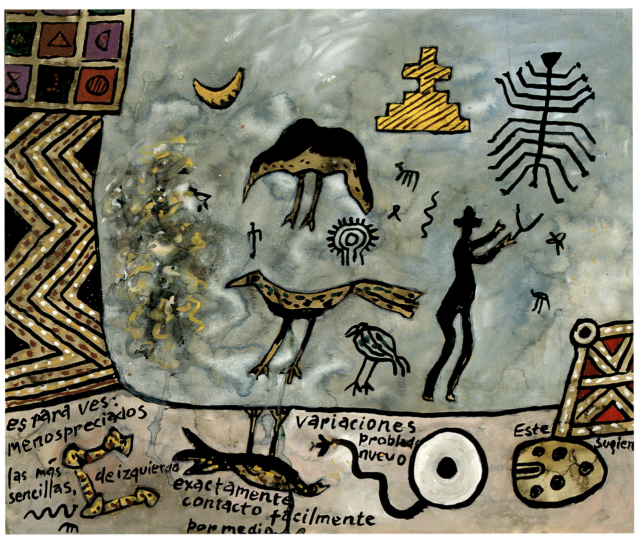

*32 **Variaciones** 1988 gouache 59.7 × 73.7 (cat.32)

this is not to be regretted: in the act of destruction (of the shamanic 'death') there is re-birth, new life. Pots of paint deliberately thrown at a canvas as an act of obliteration, or rapid attempts to paint out or destroy an image, have led to a new beginning, to the revelation of vital forms. Beneath the painted surface which we see lies a record of this process of creation and destruction, of metamorphosis, through which the artist must pass. Stages in the journey are glimpsed in passages of paint where an earlier form has won its right to participate in the final drama. As he works, Davie crosses the threshold into the myth-inflected world of the artist-shaman, and returns with a pictorial metaphor of that collective, universal world. Metaphor and allegory are the means by which myth conveys an understanding of the sacred and divine, for only obliquely can the unknown be described.

Truth is one, the sages speak of it by many names from the Hindu *Vedas*[23]

Joseph Campbell referred to myths collectively as the 'masks of God' (which both cover and reveal glory). Each myth-mask 'is a metaphor for what lies behind the visible world ... the realisation of wonder and also the experience of tremendous power ...'.[24] As has been said, Davie describes taking on the mask of a painting as he works.[25] The painting, for him, is the myth that reveals, but is not itself, the truth. Myth, then, is a language of metaphor, a type of speech which attempts to name, to clothe, to give form to the fundamental nature of reality. Myths are truths disguised in symbolic clothing (like telling a child that a baby is brought by a stork). While individual myths and their symbolic embodiment in dance, song or form can be seen as culturally determined, there are striking parallels and correspondences which reveal a commonality of experience and of response.

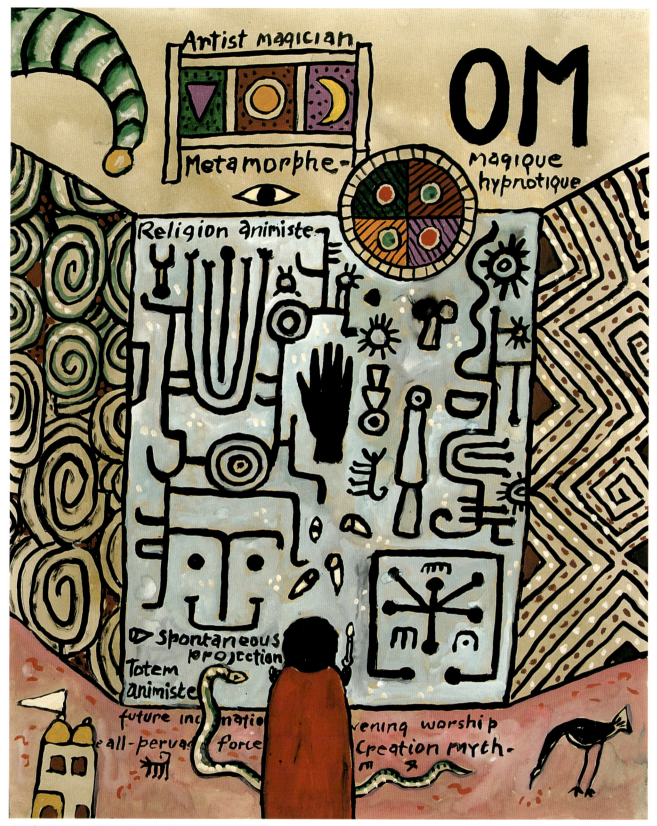

*33 **Artist magician** 1988 gouache 73.7 × 59.7 (cat.36)

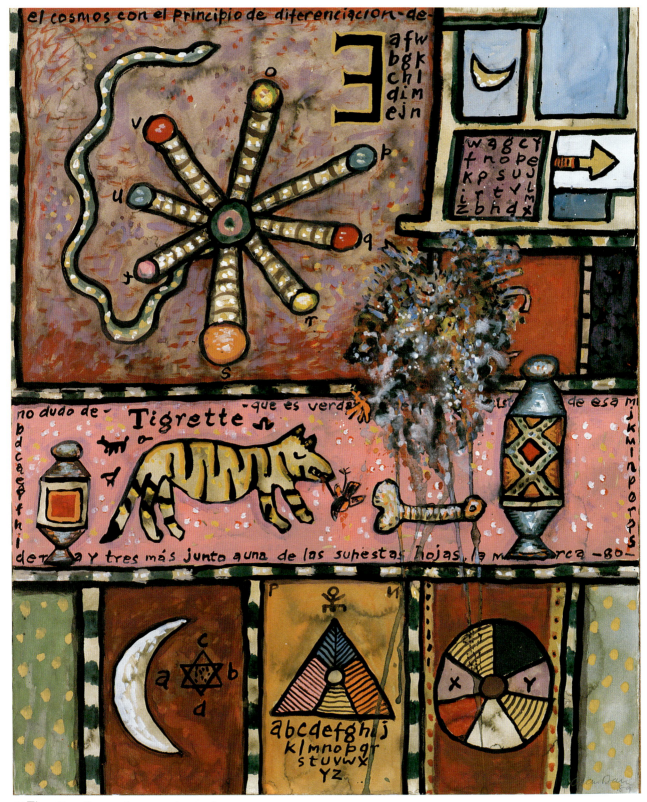

34 **Tigrette** 1989 gouache 70 × 57 (cat.117)

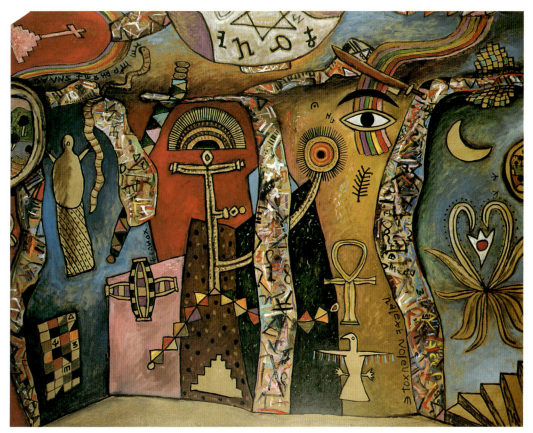

35 Il mago study no.2 1987 oil 228.6 × 289.5 (cat.91)

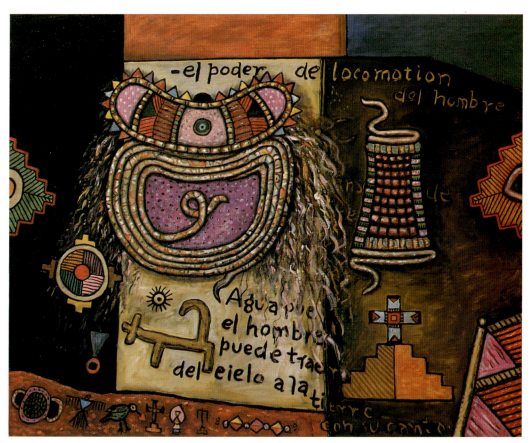

36 El poder de locomotion del hombre 1989 oil 122 × 152.4 (cat.93)

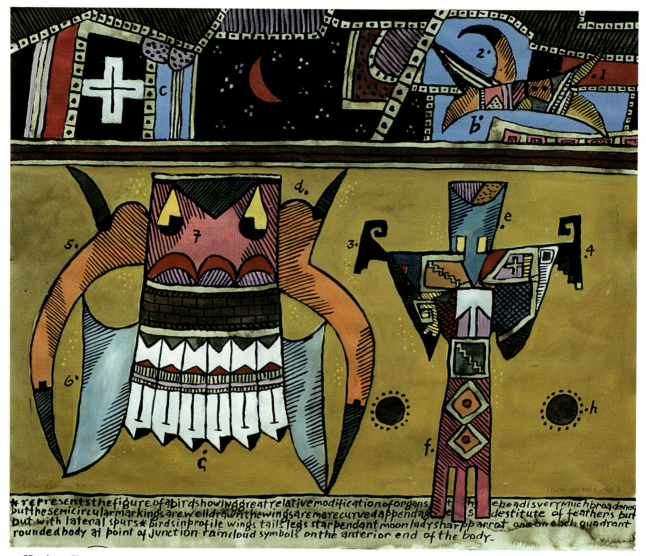

37 **Hopi studies no.7** 1990 gouache 57 × 69.5 (cat.119)

Myths therefore also provide clues to what is permanent and universal in human nature, and offer a guide to the basic truths by which mankind has lived through the millenia. In the twentieth century, psychoanalysis has demonstrated that the logic of myth continues to operate in the individual unconscious, while its language of symbols is shared at the level of the *collective* unconscious.

Myth is a metaphoric language – but so too is *all* language. Our understanding of the world is constructed metaphorically and we live (are only capable of living) a *metaphor of reality*. The challenge is to make that metaphor as rich and open to the transformative mystery of experience as possible.

There is something universally appealing in the Celtic mood and worldview ... Perhaps more than anything else, it is the magical potency of Celtic lore that attracts people today ... the (Celtic) Revival may provide a new and exciting approach to re-discovering the magic of life ...[26]

An aspect of Davie's identity as an artist which, as a fellow Scot, intrigues me is the relationship with his national inheritance. Once, when taken to task for not painting in the tradition of the Scottish Colourists, Davie retorted that far from being native, this was a tradition adopted from the French – and, indeed, that he (alone amongst his fellow Scots) painted in the tradition of his ancestors.

His work has appeared in at least one exhibition concerned with identifying contemporary manifestations of the Celtic vision (at Dublin in 1988), but I am not suggesting that *what* Davie paints is

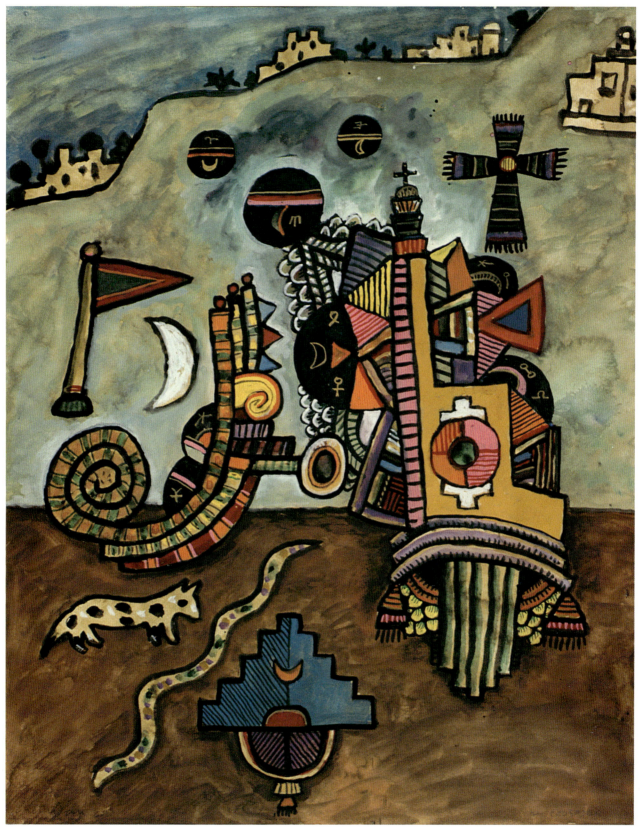

38 **Crusader** 1989 gouache 52 × 42 (cat. 118)

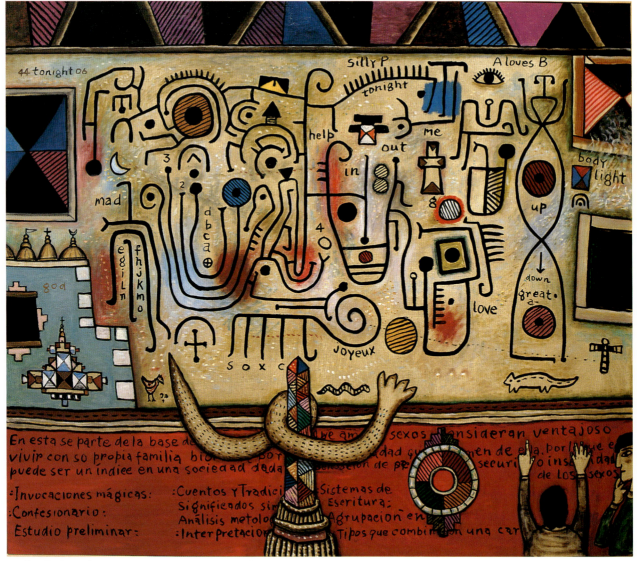

39 **Confesionario** 1989 oil 172.8 × 203 (cat.96)

inspired by his Celtic past – although he is willing to identify individual elements in his visual language as having an affinity with specific Celtic forms. I am more interested in relating the nature of his world-view, of his vision, to that of the Celts. I believe there to be a fundamental difference in the interpretation of the experience of the world between the Celtic and the Anglo-Saxon traditions. I think this is manifest in distinct approaches to the landscape that they occupy, and is traceable in the history of landscape painting even to the present day. This is not the place to elaborate my thesis, but suffice it to say that the essential difference lies in the response to nature: between *identification* (Celtic) and *observation* (Anglo-Saxon). The former implies relationship, kinship and connection, the latter separateness, alienation and possession. I hope that what I have said (elsewhere in

this essay) about the work of Alan Davie is sufficient to indicate his affinity with the former.

The inter-connectedness, the wholeness of life and the search for 'delight' in its recognition is the wellspring of the rich Celtic tradition of myth and folklore. A mobile people, whose clan-based settlements extended from Ireland to the Middle East, the Celts wrote nothing down. Theirs was a vital oral tradition of story-telling, music, song and poetry. Their myths and legends are full of heroic ordeals, magic battles and encounters with supernatural forces, which in their character and symbolism closely resemble the shamanic-heroic journeys of other native cultures – from Slav to Native American Indian. A fiercely independent, passionate and romantic people, the Celts were skilled warriors who loved adventure. Their religion was founded on a belief in reincarnation which

60

Snakes and other reptilian forms were represented by the ancient potters in the decoration of food bowls, and it is remarkable how closely some of these correspond in symbolism with conceptions still current in Tusayan.

Of all reptiles or monsters the worship of which forms a prominent element in Hopi ritual, that of the great plumed snake is perhaps the most important.

Effigies of this monster exist in all the larger Hopi villages and they are used in at least two great ri—— ——tes – the So— yaluña in December and the Palülükonti in March. The symbolic markings of the Plumed Snake effigy are found in all modern representations of this mystic being, yet there is not a single instance in which those modern markings appear, so there is doubt in regard to the identification of many of the Sikyatki serpents with modern mythological representatives.

The tail consists of two elongate feathers rounded at their outer ends and fused at the point of union with the body.

Certain simple geometric forms originally derived from bird designs were copied by these early potters to represent birds, but rather

The particular genus of birds to—

The head is triangular, and the beak continues into a large fret. The body is rhomboidal in shape, the upper portion being occupied by a patterned square. Rising above the body is a conventionalized wing, while depending from its lowermost angle is a figure resembling feathers.

—presumably without intending merely as decorative motives, which each could be referred is quite problematical.

*40 **Hopi studies no.25** 1990 gouache 68.6 × 57.2 (cat.44)

PL.CLf. lateral view of conventionalized bird:
1 feathers are among the most important objects employed in Pueblo ceremonies, and among the modern Hopi, feathers of di-fferent birds are regarded as efficacious for different specific purposes. Thus the turkey feather symbol is efficacious to br-ing rain, and the hawk and eagle feathers are potent in war. The specific feather used ceremonially by modern Hopi priests is regarded by them as of great importance. Belief in magic power of certain feathers was deeply rooted in the minds of the ancient Hopi from prehistoric times. Feather designs are found in most unexpected associations, occurring on the heads or bodies of serpents, and with other symbols attached.

41 **Hopi studies no.30** 1991 oil 172.8 × 203 (cat.97)

was so much a part of their daily lives that it was common for their bards to recall previous incarnations (not all human) in 'riddling poems', and for their warriors prior to battle to pledge repayment of a debt in the next life.

The legacy of the Celts is difficult to define, and yet its importance is increasingly acknowledged today. Their legends are the source of some of the most enduring myths which embody the universal themes of love, death, betrayal and redemption. From them come the stories of Parsifal, Tristan and Isolde, and the Holy Grail. The discipline of the passions (so essential to the heroic or shamanic role) as expressed in Arthurian chivalry also has its root in the Celtic tradition. In their characteristically linear visual art, the Celts embodied their animism in a wealth of sinuous forms in which animals (real and mythic), humans and plants entwine, unite and break free. The meaning of this rich symbolic

language can only be guessed at. The Celtic world of form was one of the most important sources of inspiration for Anglo-Saxon and Irish art and survived in its own tradition to a late flowering in the work of the early Medieval book illuminators.

In a published interview of 1989 Alan Davie, referring to the excitement of illuminated manuscripts, identifies his art with that Celtic tradition which is 'very much to do with fantastic art. To me that is what my art is about . . . a lot of the ideas are worked out in a linear way.'[27] Celtic legend and myth, and their visual embodiment in stone carving as well as in illumination, were rich in fantastic creatures, symbols and signs. Their language of art, as with so many other native cultures, was metaphoric. Their visionary means of recording their philosophic tradition through the agency of magic and the device of symbolic form has its contemporary equivalent in Davie's art.

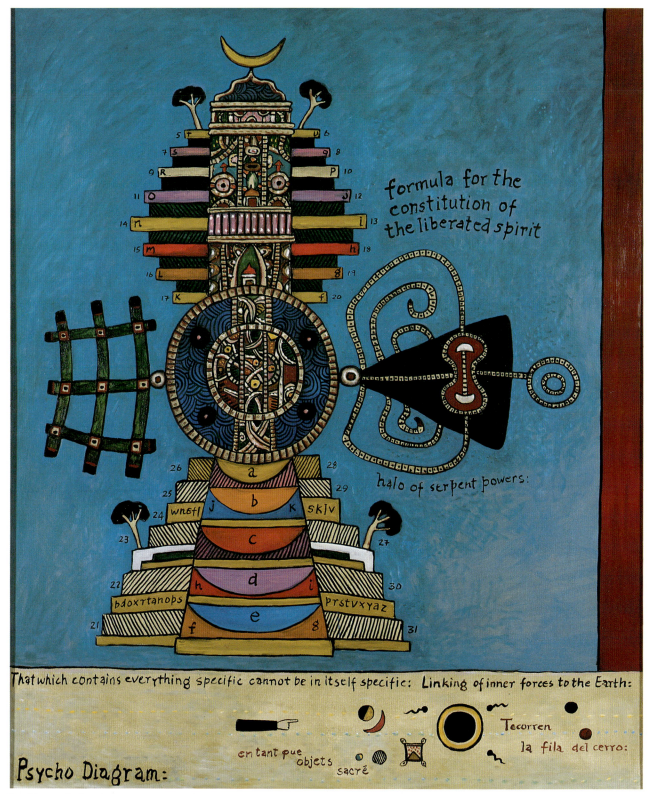

formula for the constitution of the liberated spirit

halo of serpent powers:

That which contains everything specific cannot be in itself specific: Linking of inner forces to the Earth:

en tant que objets sacré

Tecorren

la fila del cerro:

Psycho Diagram:

*42 **Formula for the constitution of the liberated spirit** 1992 oil 183 × 152.4 (cat.9)

The Hopi Way – and Half a Dialogue

The pendulum never shifts 'there are several of us'

The sun never sets 'we see only hemispheres'

I play the flute – you dance 'we return to the Peaks'

They carve the dolls,
they paint the dolls 'they never worship the dolls'

Some say no,
some say yes 'but half is always enough'

White is the east,
yellow is the north 'put down the seed'

Right is the feast,
mellow is the earth 'await the plant'

Seen through is the rest,
bread in the mouth 'harvest the corn'

Green-blue is the west,
red is the south 'live through the drought'

We came up through *sepapu* 'the hole in the world'

We speak up through *kopavi* 'the hole in the top of the head'

We wander
through the Fourth World 'Spider Spiral, Bear Spiral'

We settle and build 'Abandon your burden'

All day we prayed, but
Our Bahana, White Messiah,
Did not come 'Did not come'

Usurpers surrounded us
and stole our air 'I colour in the sand'

© *1992 Philip Ward*
The above is loosely based on four *Hopi studies*
(Alan Davie 1990), gouaches he numbers 2, 13, 21 and 23

Each head has a cross with a single dot in each quadrant probably indicating female; since the same symbols on the heads of the snakes in the snake dance are used to designate the female:

Hewüqti is also called Soyokmana a Keresan Hopi name meaning the Natacka-maid. The Keresan (Sia) Skoyo are canibal giants. One of the most prominent of all the deities in the Tusayan Olympus is the cult hero, the little War God Püükoñhoya. Hopi mythology teems with legends of this god and his deeds in killing monsters and aiding the people in many ways. He is reputed to have been one of twins, children of the sun and a maid by partheno-genetic conception.

*43 **Hopi studies no.2** 1990 gouache 68.6 × 57.2 (cat.41)

44 **Enchanted village no.1** 1992 oil 152.4 × 183 (cat.99)

*I work with the conviction that Art is something basically
natural to man; an activity motivated by a faith in the
actuality of existence which is outside and beyond knowing*
ALAN DAVIE 1959[28]

Art is a *fundamental experience* which grows out of the
human need to express our inner life and our
experience of the transcendent. In the work of Alan
Davie art is revealed as an instrument of the mystical
and spiritual aspects of man's experience. As a
'supremely religious phenomenon' art's function is to
renew and increase (in the sense of expand or deepen)
humanity.[29] Through its transcendence of our rational
(partial) selves, and by expanding our awareness of
reality, art has the capacity to re-unite our fractured
selves and make us whole.

There is ample evidence from prehistory and
contemporary native culture to support this
interpretation of art as fundamental to human
experience and as the instrument of unification – within
and without. To quote but one example, the primary
purpose of Aboriginal rock painting is to maintain the
harmony between human kind, animals and the
universe. Achieved through the continuing
performance of customary rites and rituals, such
harmony is seen to be the essential basis for a secure
life.

In the use of a vocabulary of signs and symbols from
other cultures and historical periods, Alan Davie
acknowledges continuity and kinship in the creative
act. Such motifs are signposts, marking a journey
already undertaken, signalling a trail the artist is
forging anew for himself. The elements Davie gathers
are evidence of a common attempt across time to render

45 **Souvenir of Venezuela** 1992 oil 183 × 152.4 (cat.100)

46 **Enchanted village no.4** 1992 oil 122 × 152.4 (cat. 101)

the experience of the ineffable through the concrete and the specific. By drawing on the material and mythic forms (the 'masks of God') through which diverse cultures have approached the ineffable, Davie creates a statement which contains our accumulated learning concerning communion with the transcendent.

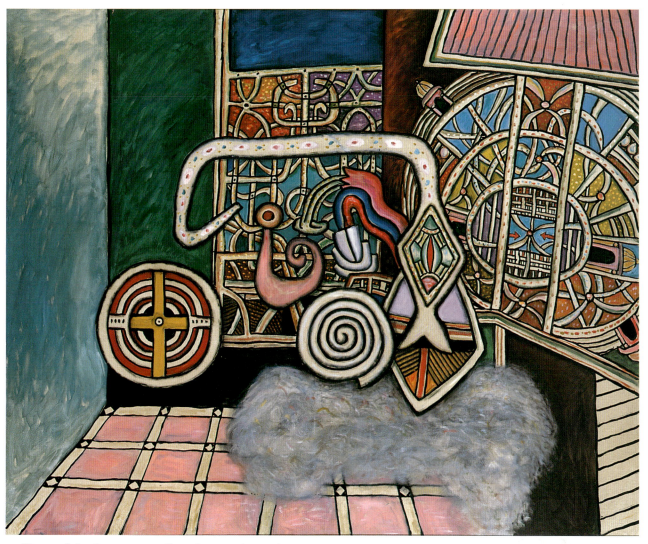

47 **Room of the shaman** 1992 oil 172.8 × 213.4 (cat.105)

What moves the spirit profoundly can never be fathomed
NEIL GUNN[30]

Alan Davie's art, a magical conjuring of the unknown forces which animate our lives, is alive with potentiality. He works in a tradition which is unconstrained by time, space or culture, with archetypal forms which through the medium of ritual, mythology and vision have inspired humanity throughout history. Our fractured world continues to need its 'cultural exemplars', the wise ones who stand at the portal to our essential selves. In his creative process, like all shamen, Davie is concerned with passage into a new realm of awareness beyond the superficial and transient. Davie's paintings therefore become for us objects of magical intimation, a means by which the mundane world gives way to the extra-ordinary and visionary. In our materialistic world, with its lack of magic and wonder, Davie's art is a call to arms. His work invites us once more to recognise the 'signals of transcendence' in the everyday,[31] and to experience anew the symbolic forms through which we may approach the mystery that is life.

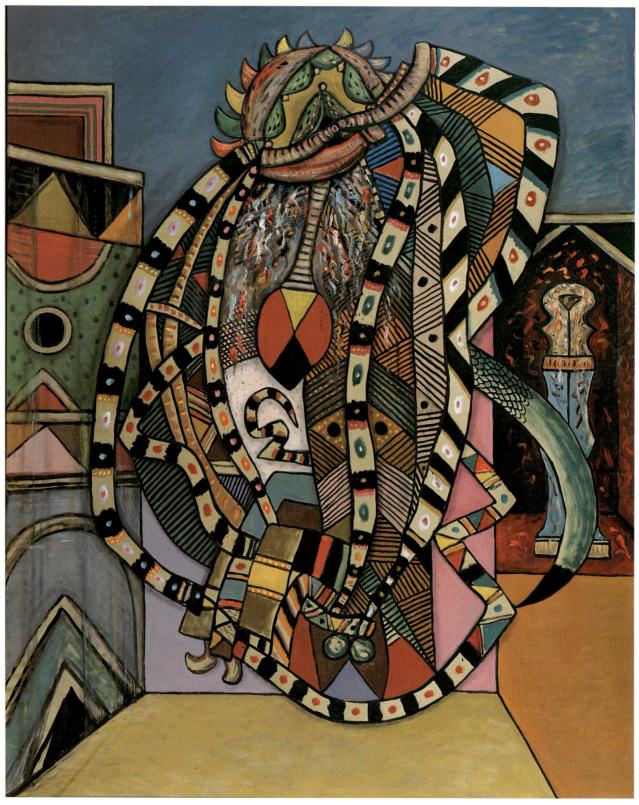

48 **Homage to an earth goddess no.9** 1992 oil 213.4 × 172.8 (cat.104)

Notes

1. The title of this essay is taken from a description of the practice of Zen in the writings of Chuang Tzu, quoted by Colin Wilson in *The Occult*, Grafton 1986 edition.

2. Alan Davie, 'Towards a new definition of Art: some notes on (NOW) painting', 28 October 1959, quoted in his exhibition catalogue for the Galerie Charles Lienhard, Zurich 1960.

3. Shunryu Suzuki, *Zen Mind, Beginner's Mind*, Weatherhill 1983 edition.

4. ibid.

5. D. T. Suzuki, *An Introduction to Zen Buddhism*, Rider Books 1991 edition.

6. Alan Davie, 'Notes by the artist' in exhibition catalogue, Whitechapel Art Gallery, London 1958.

7. Quoted in James Johnson Sweeney, *Joan Miró*, Museum of Modern Art, New York 1941; reprinted Arno Press 1969.

8. Herbert Read, *A Coat of Many Colours*, Routledge & Sons 1947 edition.

9. Quoted in J. E. Cirlot, *A Dictionary of Symbols*, Routledge & Kegan Paul 1990 edition.

10. Richard Foster, *Patterns of Thought : The Hidden Meaning of the Great Pavement of Westminster Abbey*, Jonathan Cape 1991.

11. Herbert Read, *Icon and Idea*, Schocken Books, New York 1969 edition.

12. Quoted in Cirlot op.cit.

13. This juxtaposition of contemporary with tribal art anticipated such exhibitions as the major '*Primitivism' in Twentieth Century Art : Affinity of the Tribal and the Modern*, Museum of Modern Art, New York 1984 (catalogue edited by William Rubin, 2 vols). See Michael Tucker, *Dreaming with Open Eyes : The Shamanic Spirit in Twentieth Century Art and Culture*, Aquarian/HarperSanFrancisco 1992, pp.5-8, for a discussion of the problematic aspects of this exhibition.

14. Alan Davie, 'Towards a new definition of Art' op.cit.

15. James Cowan, *Mysteries of the Dream-Time*, Prism Unity 1989.

16. Tucker 1992 op.cit. (*Dreaming*).

17. Joseph Campbell, *The Hero with a Thousand Faces*, Princeton/Bollingen 1968 edition.

18. ibid.

19. Suzi Gablik, *Has Modernism Failed?*, Thames and Hudson, 1985.

20. *The high priestess and the magician*: sculpture and fresco; cement, mirror glass and acrylic. Giardino dei Tarocchi (Tarot Garden), Southern Tuscany. Illustrated in Tucker 1992 op.cit. (*Dreaming*).

21. Alan Davie, 'Notes by the artist' op.cit.

22. Alan Davie, 'Notes on teaching' 1959, reproduced in his exhibition catalogue for the Kunsthalle, Bern 1963.

23. Ancient Hindu scriptures comprising four collections of hymns.

24. Joseph Campbell, notes to *Masks of Eternity*, a filmed interview with Bill Moyers, American TV Network.

25. Alan Davie in conversation with the author, February 1993.

26. John Lash, *The Seeker's Handbook*, Harmony Books, New York 1990.

27. Interview with Keith Patrick, *The Green Book* vol. III no.3.

28. Alan Davie, *The Developing Process*, exhibition catalogue, ICA, London 1959.

29. Laurence van der Post, interview with Bernard Levin, *The Listener* 30 June 1983.

30. Neil Gunn, *The Other Landscape*, Richard Drew 1988 edition.

31. Peter L. Berger, *A Rumour of Angels*, Pelican/Penguin 1970 edition.

Portrait of the artist:
Alan Davie at Gamels studio
Iain Roy

Alan Davie's *joie de vivre* is intense, a joy expressed as much by his love of nature and music-making as in the act of painting. At his recent Glasgow retrospective, Davie's delight in rediscovering passages from his earlier works was undisguised; no artist ever took more innocent pleasure from viewing his own achievements. Some of the works on show at Glasgow were being seen by Davie for the first time in many years, and his excitement at resuming a dialogue with these old friends was every bit as palpable as when new works begin to take shape in his Hertfordshire studio.

To visit Gamels studio is to enter an Aladdin's Cave full of riches. Home to Alan and Bili Davie for many years, much of the interior decoration is of the artist's making, and his own works are complemented by a fascinating collection of tribal objects. At the heart of the house, a music room reminds one that Davie does not regard painting as an exclusive activity.

Upon entering the studio itself, one is constantly astonished by the sheer vitality of Alan Davie's boundless creativity.

Works in progress

The purpose of art is the renewal of the act of creation and constant renewal of the relationship with God

By the slightest tilting of his head, and now and then a fleeting smile or a barely perceptible raising of an eyebrow, Alan Davie registers transient emotions as he pulls out painting after painting from the stack at the end of his studio. He pauses as each picture awakens memories and stimulates fresh visions in his imagination. The artist's gestures are both contemplative and expressive. His hands, bright as alabaster under the studio lights, seem to be in silent communion with the images, as if touching them into life.

Davie's method of developing pictorial ideas from small monochromatic drawings (the very germ of his creativity), via improvisations in gouache, to large oils, follows a demonstrably evolutionary process. But there is nothing mechanistic about it, and, although he has produced successive series of works linked by specific themes, Davie's art is not the product of a linear stylistic development. A meticulously documented catalogue of works proves that the robust, autographic approach which became his hallmark in the 1950s and 1960s has not been extinguished by a more overtly disciplined approach. In fact, a kind of synthesis has occurred in his most recent work, where complexities of form and space signify no lack of boldness in taking on difficult pictorial challenges. Sometimes a work may still emerge as the product of a single bolt of energy, executed in one continuous bout of inspired activity – though it is now more usual for large oils to gestate over considerably longer periods. As in some of Picasso's late work, unlikely marriages are reached as if they were inevitable. Such abrupt juxtapositions of style are entirely consistent with Davie's beliefs about the essential nature of artistic expression.

The gouaches lie at the heart of Alan Davie's creative process. These voyages of pictorial discovery are modest only in terms of their scale. Many retain the spontaneity and directness of the black-and-white drawings. (Is there an artist in Britain today who can match the expressiveness of Davie's graphic touch?) Some may be worked up with a degree of 'completeness' commensurate with the major oils – for which they might be studies or maquettes, jewel-like in their intensity. Brilliantly inventive and improvisatory, his gouaches epitomise Davie's ability to move seamlessly from the playful to the profound; the innocent eye of a child's wonderment at the World is simultaneously the eye of the Seer. Across maps of many colours, we are transported on a carpet of dreams

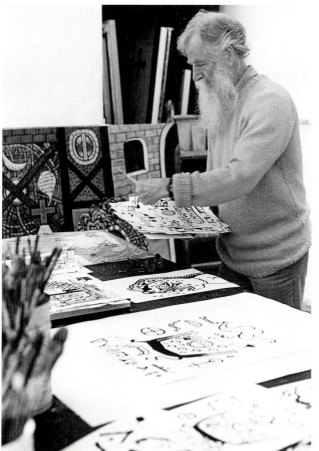

to magical places: here a small bird contemplating the moon, there a glimpse of a tropical paradise or perhaps an exotic altar to some strange, albeit unthreatening, Hindu deity.

Ostensibly, Alan Davie's sources are manifest in symbols appropriated from many lands; yet his real inspiration remains intuitive, welling up from that mysterious inner and indefinable source which eludes rational explanation. However, he vehemently refutes the popular creed that art is *self*-expression – which so often leads blindly to a creative cul-de-sac. (The *ego* is the first impediment that must be surmounted on the pathway to the liberated spirit.)

Davie is a visionary artist. His images are the hybrids of dreams; meeting-places of outer and inner worlds. Recognising he is at that kind of threshold where objects are susceptible to startling shifts in appearance and are unlikely to behave predictably, Davie believes the artist must enter into a sensitive dialogue with his paintings, rather than merely impose his will on the canvas. He becomes excited when colours *begin to sing*, and responds positively to the cross-rhythms of the patterns which he has created. Forever alert to fresh pictorial possibilities, Alan Davie is a slave to no single language.

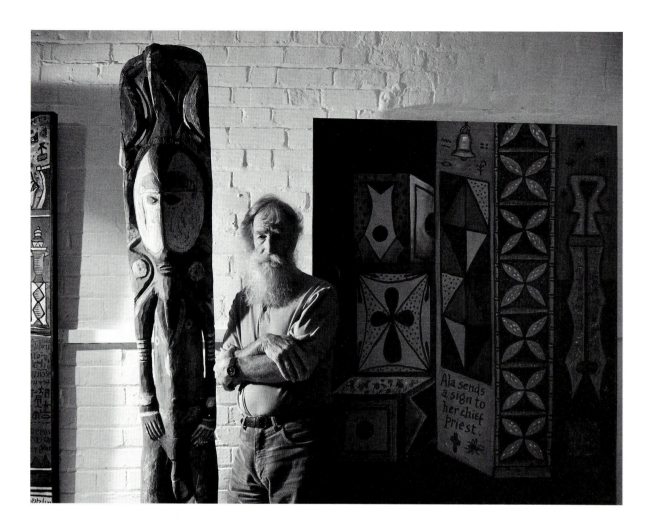

Everything is allowed
any possible form or shape and decorative
design to create a mighty image of force terror
and violent movement

So reads the inscription on one of his recent paintings.

Davie works with an undiminishing passion, finding energy which would be remarkable for a man half his age. A studio full of new work testifies to his prodigious creativity. Ten or more substantial oils may yet undergo significant transmutation before they are exhibited. The theme of these works in progress extends an already wide repertoire of references. Following earlier forays into the symbologies of primitive Europe, India, Australasia and the Americas, Davie has now turned to African mythology. In a temporary juxtaposition, the bright stripes and shamanic emblems of a late *Hopi study* hang somewhat incongruously beside a magnificent 'altarpiece', wrought in deeper hues, the colours of earth, sky and fire. The new works are dedicated to Ala: Mother of mothers, a primal icon of fecundity and creation. Texts incorporated in the 'Ala' paintings echo Davie's

intense, Blakean commitment to the act of painting as a sacred imperative:

Ala as goddess of creation demands from her worshippers that from time to time they exercise their divinely inspired faculty of creation. The object of art is in itself relatively unimportant

Perhaps so, but, in giving form to these acts of devotion, it is Davie's special gift to lead us all to the domain of the magical, the sacred, and the transcendent spirit.

The Chief Priest of Ala

Ala calls for a new building

An entire wall of the studio is lined with paintings dedicated to the supreme Mother of Earth, guardian of the seed and the harvest: a vibrant frieze of pattern, colour and incantation. A shrine to Ala.

Ala sends a sign to her chief priest

The celebrant re-composes the icons. He turns and, with palms facing outwards, slowly raises both arms.

The priest seeks confirmation

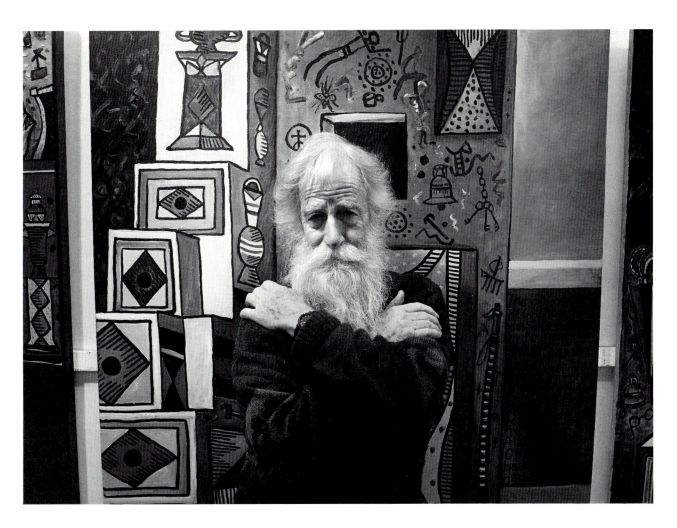

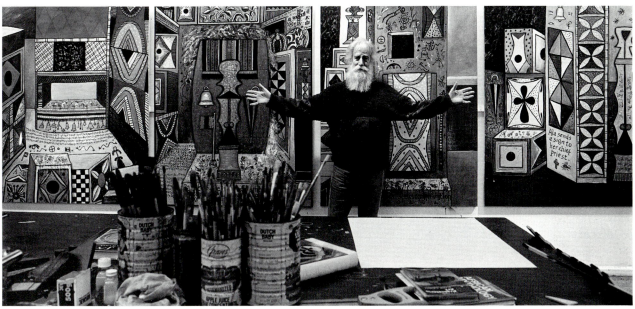

Colours in sound

Phrases of Vivaldi resonate through the stillness of a
winter-darkened room;
a pool of light on the incandescent ladder at its heart.
Half-hidden presences: tribal objects, totem, paintings.
Listening.

A pause.

Then, three chords, repeated – *insistently*.
Unexpected, yet strangely familiar colours.
'Just listen to that!'

Colour is like a chord struck on a harp, in darkness

Homage to the image-maker

Strange business

Being a painter in Britain is a strange business. The English don't quite know what to think, or do about painting. They prefer it offshore, and do their best to keep it there. When they do let it drift inland they like it clear-cut, either figurative or abstract, a story or a formal problem. Beyond that they get stuck and as the going gets rougher they give up, get lazy. The idea that they might open up their heads, get their psyche and bodies dirty, let loose the subconscious or the animal in themselves, is sure to guarantee that they head straight back to the island.

So when a painter like Davie comes along, who sits full square in the rough ground, together with a few colleagues such as Roger Hilton, he is seen as an oddball, not quite fitting in or playing the game, and so is kept offshore – and we are the poorer for it. Our roots, our real roots, the Celts, old blood, the bogs, the liquid and flow of our early history is lost, suffocated under the weight of the Academy. Reynolds, Lawrence, the list is long and continues. What an impoverished tradition of mediocrity we painters have to fight our way out of. Even Turner and Constable are soothed in this land of the pastoral. Schhh! lest we wake the monster in this beautiful land.

It makes you want to scream out loud 'Let the land devour me down to mud and all, but do not placate me!' So when Davie lets loose his stream and flow that seeps inside the knowing brain, I take off my hat with respect and await the ferment in the tide.

IAN McKEEVER

Process and presence

I first saw Alan Davie's work in the fifties. It was apocalyptic. His trajectory seemed higher than anyone else's. The aspirations for painting limitless, the scale of achievement already enormous. A revelation.

Robert Melville referred to Davie's 'sense of the wonder and mystery of the process *of creating a picture that gives the work its presence'.*

In 1962, the huge RBA Galleries couldn't contain his work, its quality and quantity overwhelmed the Galleries and all of us who saw it. He's an inspiration.

When I gave up teaching at Goldsmiths', I couldn't believe my good fortune when I was handed my leaving present – an Alan Davie!

ALBERT IRVIN

The power of enchantment

Alan Davie says that 'colour is magical like a chord struck on a harp in the darkness'. To enchant, in its original rather than its more recent romantic sense, meant to cast a spell, to wrap or bound someone or something within the chords of a magical chant. Magical because the sound itself emanated from the depths of the collective unconscious. Deeper, even. The chant was a sound which wove together the web of life, the very patterns and shapes of the cosmos. In so doing, enchanters not only reflected deep reality, they shaped it, conjured it into form.

Alan Davie's paintings enchant. Miniaturised in a book of his work, they jostle about like entries in a spellbook, their shapes, relationships, patterns – especially their colours – singing magical chords. In an exhibition, at their original size, they have more room and can sing their spells at full volume. At the moment of creation, even in the literal silence of work, their sound must be thrilling, terrifying, perhaps awe-inspiring. We must be grateful to Alan Davie for serving as our spell caster, reaching far into the collective sources of knowledge and drawing into view pulsating fibres of power, of insight and meaning. A process in which enormous energies must be contained, directed, wrestled into being. We are willing witnesses, participants, in his process of magic.

DR BRIAN BATES

A little smoke signal

'How much more important than Art', cries Alan Davie, 'just to be a bird!' To many, ensconced in some all-too-human enclosure ('art-world' included), the statement will seem fey, that is, romantically pathetic. Let's take it seriously, seeing in it one of the oldest human aspirations, manifested in various modes, from the magdalenian bird-dance, through Jacob Böhme's 'bird-language' to Charlie Parker's ornithomania: the desire to be in touch with some rhythmically live and semantically rich totality. Without that, art is so much lumber. Senseless accumulation, infantile or senile palaver, ideological sub-product. I'm alluding to something deeper and more high-flying too than religion. Compared to religious doxology, the one valid in this primal context might be: 'Thine is the wingdom, the power and the beauty, cosmos without conclusion, ah!' This total implication which shaman and art-man have always tried to get at can come across in the

deep resonance of a taoist dreamstone (three rough traces of black on a cold white gritty ground, and you have a whole range of implicit possibility). Or it can come across in some colourful icono-ecstatic cosmology. Davie, an outsider on fertile ground with large foundations, to my liking, has always been aware of both : the empty way and the full way, the austere-hyperborean way and the tropical-tantric way. There need be no excluding, no choosing. Left hand, right hand. Caledonian gulls, Cornish crows, Caribbean parrots : one world, terraqueous and windy, and a body-mind, cosmopoetically, in action. Kaka-kaya gaya-ka! All that increases the (de)light of being on earth. All that mutters and matters. Transatlantic and transhuman salutations.

KENNETH WHITE

Making colour sing

As defined in my Oxford Dictionary 'Miraculous' refers to the supernatural and wonderful, two entirely appropriate words for Alan's work given his long-term interest in symbolism etched by past inhabitors of this earth. His painting and music invite us to a kaleidoscopic world full of mystery and meaning. The colours dance and vibrate, uplifting our spirits.

These last words sum up my first encounter with Alan when, as musicians some seventeen years ago, we were preparing for an English tour of improvised music with percussionist Tony Oxley. Then as now I was energised by Alan's work, which has recently challenged me in a new way.

Alan commissioned me to write a work for the final concert in a series that took place at the McLellan Galleries, Glasgow during his major retrospective in 1992. The piece called for an improvising soloist (without score) and a straight ensemble (with score) and takes its title Bird gong game *from painting Number 12 in the* Bird gong *series. Here was an exquisite moment to deconstruct a painting of Alan's and transfer the sign-language from the visual to the aural so that it could influence a musical argument. The parameters are wide, with great flexibility, so that musical implosion and explosion can happen in the time it takes the director to indicate the playing areas to the ensemble.*

In a sense Bird gong game *is indicative of the procedures Alan employs in his work and I think I was guided by special forces when planning the strategy. The piece has mystery inbuilt and listeners often comment upon the unusual radiance and energy of the music.*

The soloist in the Glasgow concert was Alan himself playing piano which completed the circle of Artist-Musician/Painting/composer/score/Artist-Musician. As Alan said in a preview to Bird gong game *: 'I've always been a painter and a musician – to me the two are interchangeable'. In a very special way Alan opened the door to a closer understanding of his art. Instead of just looking on I was at last inside the process.*

My partner Maya Homburger and I visit Alan and Bili often now. Like myself seventeen years ago, Maya has been moved by the deep qualities in Alan's work. We always leave the studio elevated and refreshed, sure of the fact that, in a miraculous way, he has put us in touch with the earth spirits again.

BARRY GUY

Wizard of the brush

Alan Davie is an artist of flair and flourish who dazzles us with his brave bright endless flow of paintings.

After a visit to Alan's studio you come away invigorated by the sheer force of the man's commitment to his talent and art. His sense of wonder flows from the end of his brush and you cannot help being entranced by his passionate vigour ; the powerful imagery punched onto the canvases, and delineated with his customary black lines floating on a sea of beautifully vibrating colour. What a life force runs through these paintings. They lift you out of the 'hum-drum' of daily life onto a higher aesthetic plane.

Over the years he has produced many masterpieces. His interest in Zen Buddhism and his searches into the multifarious cultures of the world feed his vision and from this vision come the mysterious paintings which enthrall us.

Alan Davie is indeed a magical artist.

JOHN BELLANY

Bold traveller

Alan Davie :

Bold traveller
painting our voyage
through time.

A vessel sailing
upon seas of visions.

Hearing divine voices.

Hunting lost immortality
In the labyrinth
of dreams.

　　　　Hilsen

FRANS WIDERBERG

Your mind takes us fast
and far
through a borderless landscape
of dream and symbol.
　　　Ha det bra, Alan!

JAN GARBAREK

Chronology

1920
September 28: James Alan Davie born at Grangemouth, Scotland, the son of a painter and etcher.

1937
September: Entered Edinburgh College of Art.

1938
Awarded Andrew Grant Scholarship, made silver jewellery.
Beginning of interest in jazz.

1940
Awarded Diploma, Edinburgh College of Art.

1941
Awarded Andrew Grant Travelling Scholarship. Left Edinburgh College of Art to do war service in the Royal Artillery.

1942
Received Guthrie Award for the best painting by a young artist at the Royal Scottish Academy summer exhibition.

1943
Began to write poetry as a main creative activity.

1946
January: Demobilised from the army and returned to Edinburgh.
At first taught art to young children, then began painting again. Beginning of deep interest in primitive art.
First one-man exhibition in an Edinburgh bookshop.

1947
For a short while became a full-time jazz musician, playing tenor saxophone with Tommy Sampson's Orchestra.
October 29: Married Janet Gaul, an artist-potter, in Edinburgh.
Began making and selling silver jewellery.

1948
April 5: Took up travelling scholarship (awarded 1941) and left Edinburgh permanently to travel through Europe.
November (late): In Venice, for exhibition at Galleria Sandri (December 1-15). Mrs Peggy Guggenheim buys *Music of the autumn landscape*. Saw modern paintings in her collection, including early work by Rothko, Motherwell and Jackson Pollock.

1949
February 13: Left Italy to travel in southern France and Spain.
March 30: Returned permanently to London.
Made a living by making jewellery in gold and silver, and playing jazz.
Talents recognised by Gimpel Brothers. Beginning of their intimate friendship and encouragement.
September 24: Birth of daughter, Jane. Experiments with sculpture in metal and plaster.
Mobiles with dried grasses.

1950
September: First one-man exhibition at Gimpel Fils.
December: First contacts with Herbert Read and Roland Penrose at opening of the Institute of Contemporary Arts.

1953
September: Began experiments in teaching methods for adolescents, at the Central School of Arts and Crafts, London.

1955
Interest in Zen Buddhism and oriental mysticism.

1956
March: Painting purchased by Contemporary Art Society from Gimpel exhibition.
March/April: Visited New York, for first American one-man exhibition at Catherine Viviano Gallery. Paintings purchased by Museum of Modern Art, and Albright Art Gallery, Buffalo. Met Pollock, Kline, De Kooning, Motherwell and Rothko.
October: Awarded Gregory Fellowship in Painting at the University of Leeds.

1957
Elected member of the London Group.

1958
March: Retrospective exhibition at Wakefield, shown in June at Whitechapel Art Gallery.
October: Painting purchased by the Tate Gallery.

1959
July: Gregory Fellowship comes to an end: leaves Leeds.

1960
Took up sport of gliding.

1962
Large exhibition at RBA Galleries, London, and at the Stedelijk Museum, Amsterdam, later touring Europe.

1963
One-man exhibition in British section of VII Bienal at São Paulo, Brazil: awarded prize for best foreign painter.
Began series of many watercolours.
Lithographs published by Alecto Editions, London, 'Zurich Improvisations'.

1966
Awarded First Prize, International Print Exhibition, Cracow.

1967
Alan Davie, edited by Alan Bowness, published by Lund Humphries, London.

1970
Lithographs published by Mathieu Zurich, 'Fox Watch'.

1971
First public recital of music, Gimpel Fils Gallery, London.
Alan Davie Music Workshop, first record published.
Tate Gallery recital of music, organised by The Young Friends of the Tate.
Camden Arts Centre, painting exhibition in conjunction with music recital.

1972
Three records published.
Awarded CBE in Queen's Birthday Honours.
Murals for school in Berlin, commissioned by architect Peter Haupt.

1973
ADMW music concert in Gimpel Fils Gallery with painting exhibition.

1974
Tapestry design commissioned by Barry Cronan, executed in Ireland.
Began designing tapestries in editions of six for Gimpel Fils Gallery (14 editions executed). Wintered in the Caribbean island of St Lucia, returning annually until 1991.

1975
Music concert in Musée d'Art Moderne, Paris.

1976
Graphic Prize, Museum of Contemporary Art, Ibiza.
Saltire Award, Mosaic in Grangemouth, Scotland.

1977
Summer Term lecturer at Royal College of Art, London.
Honoured by the Royal Scottish Academy, Edinburgh (HRSA).

1979
Visit to Australia, exhibition in Sydney.

1987
Awarded Order of the Southern Cross, Brazil.

1991
Royal College of Art Convocation: Senior Fellow.
Lecture at Arnolfini Gallery, Bristol.

1992
Retrospective at McLellan Galleries, Glasgow, touring to Royal West of England Academy, Bristol. Exhibition at Talbot Rice Art Gallery, Edinburgh and British Council touring exhibition to Brussels and South America.

List of works

All works are in the collection of the artist unless otherwise indicated. Dimensions are given as height before width, centimetres before inches. Opus numbers are indicated in brackets.

Brighton Festival exhibition 1993 'Alan Davie: The Quest for the Miraculous' University of Brighton Gallery (and other venues)

OILS

1 [pl.8]
Crazy ikon 1959 (0258)
oil on canvas 213.4 × 172.8 (84 × 68)

2
Oh what a beautiful bird 1961 (0384)
oil on canvas 213.4 × 172.8 (84 × 68)

3
Dragons eggs assorted 1964 (0488)
oil 152.4 × 183 (60 × 72)

4 [pl.13]
Serpent swallows the fairy tree no.2 1971 (0698)
oil on canvas 152.4 × 183 (60 × 72)

5
Magic picture no.55 1977 (0859)
oil on canvas 122 × 152.4 (48 × 60)

6
Mystical vision, spinning cross 1985-6 (01059)
oil on canvas 195.5 × 152.4 (77 × 60)

7
Mystical landscape, flying serpent 1986-7 (01074)
oil on canvas 172.8 × 213.4 (68 × 84)

8
Ritual worship 1988 (01153)
oil on canvas 122 × 152.4 (48 × 60)

9 [pl. 42]
Formula for the constitution of the liberated spirit 1992 (01191)
oil 183 × 152.4 (72 × 60)

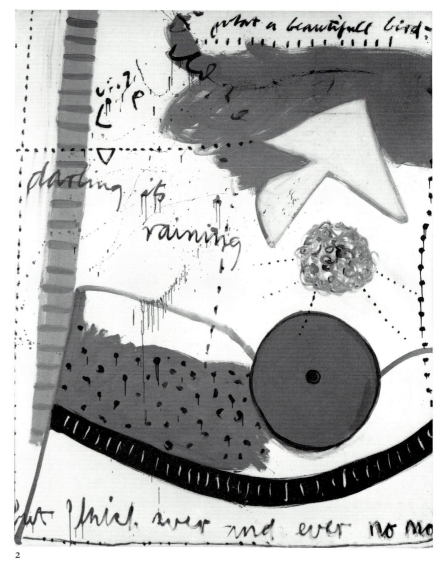

2

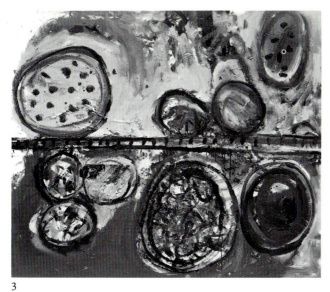

3

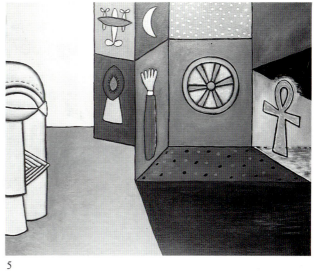

5

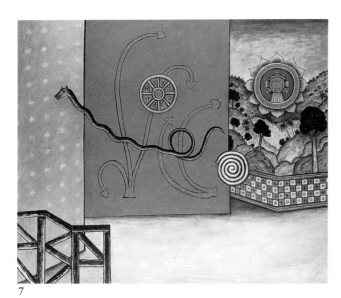

7

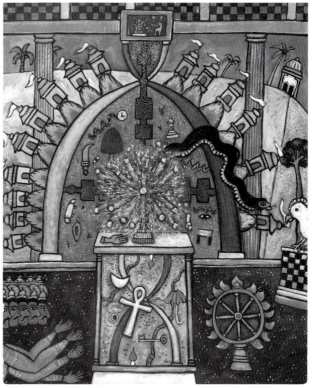

6

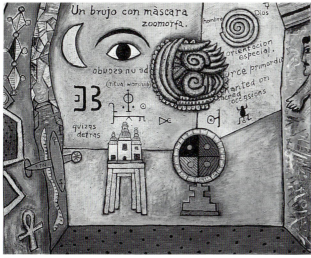

8

10
The studio no.2 1974 (G886)
gouache 52 × 68.5 (20½ × 27)

11
The studio no.9 1974 (G893)
gouache 52 × 68.5 (20½ × 27)

12
The studio no.12 1974 (G896)
gouache 52 × 68.5 (20½ × 27)

13
Black magic 1974 (G923A)
gouache 59.7 × 84 (23½ × 33)

14 [pl.16]
Night improvisation no.7 1975 (G954)
gouache 52 × 77.5 (20½ × 30½)

15
Moon and rainbow wall 1975 (G971)
gouache 59.7 × 84 (23½ × 33)

16
Summer improvisation no.3 1975
(G981)
gouache 53.3 × 77.5 (21 × 30½)

17
Tropical landscape no.8 1976 (G1030)
gouache 59.7 × 84 (23½ × 33)

18 [pl.18]
Homage to the Caribs no.20 1976
(G1107)
gouache 59.7 × 84 (23½ × 33)

19
Carib islands no.3 1976 (G1151)
gouache 59.7 × 84 (23½ × 33)

20
Diagram from a north coast 1976
(G1183)
gouache 59.7 × 84 (23½ × 33)

21
Magic picture no.3 1977 (G1205)
gouache 59.7 × 84 (23½ × 33)

22 [pl.20]
Magic picture no.43 1977 (G1245)
gouache 59.7 × 84 (23½ × 33)

23
Magic picture no.46 1977 (G1248)
gouache 59.7 × 84 (23½ × 33)

24 [pl.17]
Zen poem no.7 1977 (G1327)
gouache 59.7 × 84 (23½ × 33)

13

16

17

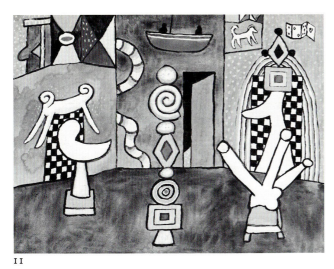

11

20

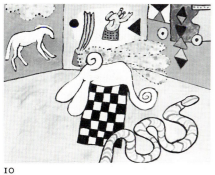

10

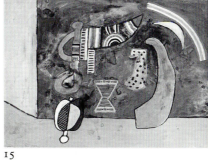

15

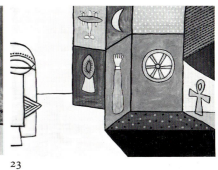

23

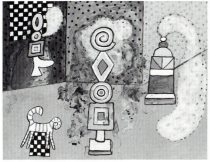

12

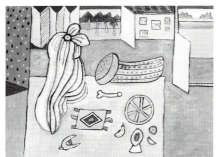

21

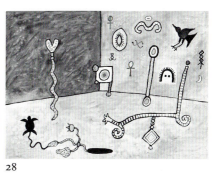

28

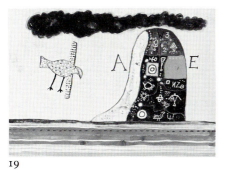

19

25 [pl.23]
Yoga structures no.42 1978 (GI414)
gouache 59.7 × 84 ($23\frac{1}{2}$ × 33)

26 [pl.22]
Homage to the earth spirits no.31A
1980 (GI635A)
gouache 59.7 × 84 ($23\frac{1}{2}$ × 33)

27 [pl.21]
Homage to the earth spirits no.50
1980 (GI655)
gouache 59.7 × 84 ($23\frac{1}{2}$ × 33)

28
Songs of the grackle no.14 1982
(GI786)
gouache 59.7 × 84 ($23\frac{1}{2}$ × 33)

29
Mystic vision. The musician 1985
(G1884)
gouache 59.7 × 73 ($23\frac{1}{2}$ × $28\frac{3}{4}$)

30
Mystical landscape no.5 1986 (G1928)
gouache 73 × 59.7 ($28\frac{3}{4}$ × $23\frac{1}{2}$)

31 [pl.28]
Mystical landscape no.17 1986 (G1940)
gouache 59.7 × 73 ($23\frac{1}{2}$ × $28\frac{3}{4}$)

32 [pl.32]
Variaciones 1988 (G2039)
gouache 59.7 × 73.7 ($23\frac{1}{2}$ × 29)

33
La repeticion de simetria en el arte
1988 (G2040)
gouache 59.7 × 73.7 ($23\frac{1}{2}$ × 29)

34 [pl.31]
Il mago study no.3G
1988 (G2041)
gouache 59.7 × 71.7 ($23\frac{1}{2}$ × 28)

35
Manifestaciones artisticas 1988
(G2044)
gouache 59.7 × 73.7 ($23\frac{1}{2}$ × 29)

36 [pl.33]
Artist magician 1988 (G2071)
gouache 73.7 × 59.7 (29 × $23\frac{1}{2}$)

37
Cultural cognitive maps 1988 (G2072)
gouache 73 × 59.7 ($28\frac{3}{4}$ × $23\frac{1}{2}$)

38
Constellations no.3 1989 (G2075)
gouache 68.6 × 55.8 (27 × 22)

39
Tree of life 1989 (G2092)
gouache 68.6 × 57.2 (27 × $22\frac{1}{2}$)

40
Mystic wall 1989 (G2096)
gouache 59.7 × 68.6 ($23\frac{1}{2}$ × 27)

41 [pl.43]
Hopi studies no.2 1990 (G2114)
gouache 68.6 × 57.2 (27 × $22\frac{1}{2}$)

42
Hopi studies no.13 1990 (G2125)
gouache 55.8 × 67.3 (22 × $26\frac{1}{2}$)

43
Hopi studies no.21 1990 (G2133)
gouache 66 × 55.8 (26 × 22)

44 [pl.40]
Hopi studies no.25 1990 (G2137)
gouache 68.6 × 57.2 (27 × $22\frac{1}{2}$)

BRUSH DRAWINGS

10 works, 1989-92, various dimensions

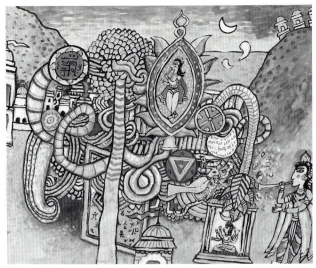

29

33

35

30

37

43

39

38

42

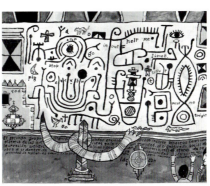

40

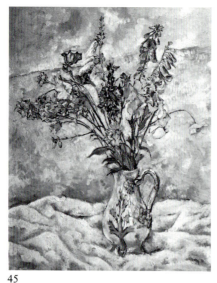

45

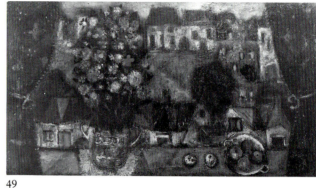

49

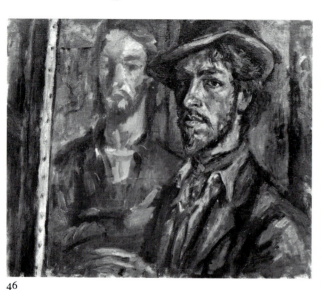

46

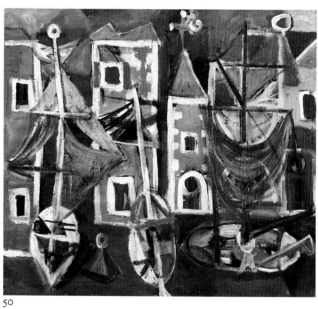

50

OILS

45
Flowers in a jar 1937 (03)
oil on wood 66.2 × 54 (26 × 21¼)

46
Self-portrait with soft hat 1940 (012)
oil on canvas 61 × 73.5 (24 × 29)

47 [pl.2]
Woman arranging flowers 1945 (019)
oil on canvas 68.6 × 88.2 (27 × 34¾)

48 [pl.3]
Sunset 1946 (021)
oil on canvas 61 × 91.5 (24 × 36)

49
**Landscape with window ledge and
flowers** 1946 (022)
oil on wood 44.1 × 78.4 (17½ × 30)

50
Chioggia 1948 (031)
oil on paper 78.4 × 85.6 (30 × 33¾)

51
The saint 1948 (032)
oil on paper 117.6 × 85.6 (46¼ × 33¾)

52
Entrance to a paradise 1949 (038)
oil on board 152.4 × 122 (60 × 48)
The Trustees of the Tate Gallery,
London

53
Ghost creation 1951 (067)
oil on board 122 × 152.4 (48 × 60)
Arts Council Collection

54
Blue triangle enters 1953 (097)
oil on board 147 × 176.4 (57¾ × 69½)

55 [pl.5]
Yes 1955 (0129)
oil on board 160 × 241.2 (63 × 95)

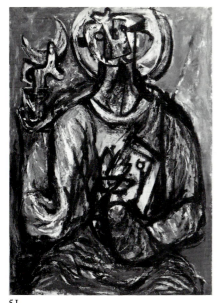

51

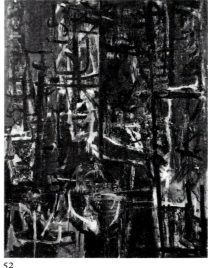

52

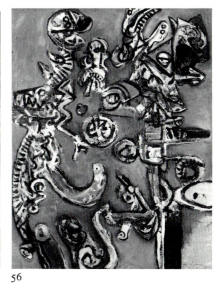

56

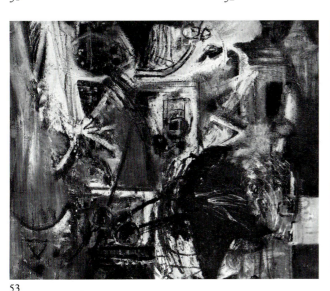

53

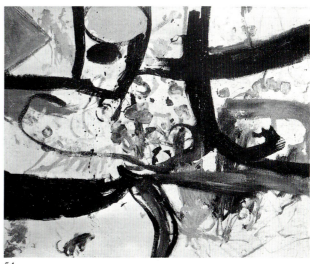

54

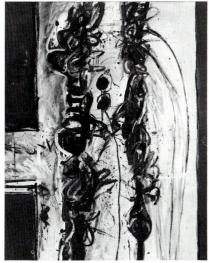

60

56
Articulated masks 1956 (0161)
oil on board 152.4 × 122 (60 × 48)

57 [pl.4]
Sacrifice 1956 (0196)
oil on board 244 × 320 (96 × 126)
The Trustees of the Tate Gallery,
London

58 [pl.1]
Farmer's wife no.2 1957 (0217)
oil on canvas 213.4 × 172.8 (84 × 68)

59 [pl.6]
Creation of man 1957 (0218)
oil on canvas 213.4 × 366 (84 × 144)
Gimpel Fils

60
Anthropomorphic figures no.1 1958
(0242)
oil on canvas 213.4 × 172.8 (84 × 68)

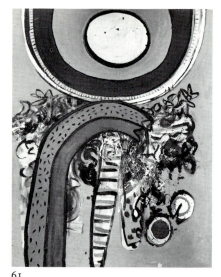

61

62

63

65

69

61
Portrait of a buddhist 1960 (0264)
oil on canvas 213.4 × 172.8 (84 × 68)

62
Entrance for a red temple no.1 1960
(0315)
oil on canvas 213.4 × 172.8 (84 × 68)
The Trustees of the Tate Gallery,
London

63
Lush life no.1 1961 (0418)
oil on canvas 213.4 × 172.8 (84 × 68)

64 [pl.7]
The red dwarf 1962 (0458)
oil on canvas 213.4 × 366 (84 × 144)

65
It's heavenly inside 1962 (0485)
oil on canvas 213.4 × 244 (84 × 96)

66 [pl.9]
New diptych for crystal gazers 1963
(0522)
oil on canvas 183 × 304.8 (72 × 120)

67 [pl.12]
Wheels for the sweet life 1965 (0568D)
oil on canvas 122 × 152.4 (48 × 60)

68 [pl.10]
**Improvisations on a Chagall theme
no.4** 1967 (0579C)
oil on canvas 172.8 × 213.4 (68 × 84)

69
Yellow pointer no.2 1968 (0596A)
oil on canvas 183 × 152.4 (72 × 60)

70
Barbaric tales no.2 1968 (0596H)
oil on canvas 172.8 × 213.4 (68 × 84)

71 [pl.11]
Moon maiden walls no.2 1970 (0623)
oil on canvas 122 × 152.4 (48 × 60)

72
Guru mask no.16 1971 (0661)
oil on canvas 122 × 152.4 (48 × 60)

73
Witch gong no.10 1973 (0712)
oil on canvas 78.4 × 101.6 (30 × 40)
Gimpel Fils

74
OM no.17 1974 (0765)
oil on canvas 152.4 × 183 (60 × 72)

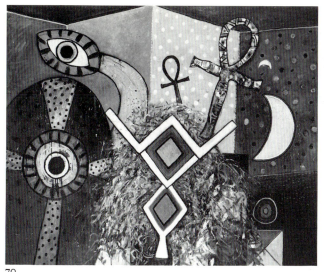

70

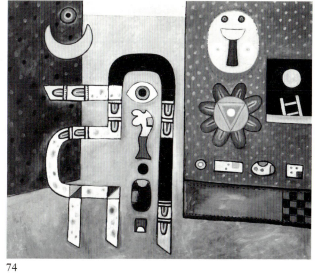

74

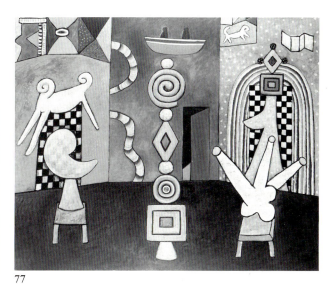

72

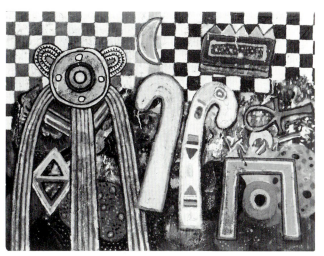

77

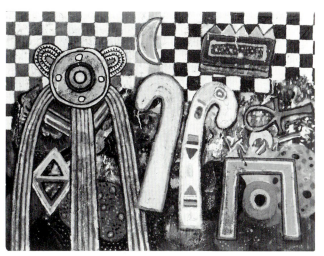

73

75 [pl.15]
Magic lamp no.27 1974 (0776)
oil on canvas 152.4 × 183 (60 × 72)

76 [pl.19]
The studio no.28 1975 (0793)
oil on canvas 152.4 × 183 (60 × 72)

77
The studio no.30 1975 (0795)
oil on canvas 172.8 × 213.4 (68 × 84)

78
Monument for S no.5 1975 (0803)
oil on canvas 152.4 × 183 (60 × 72)

79 [pl.24]
Study for a figure mask no.24 1977
(0877)
oil on canvas 78.4 × 101.6 (30 × 40)

80
Spirit chaser no.8 1980 (0949)
oil on canvas 183 × 251.5 (72 × 99)

81
Giant fish hunt no.1 1980 (0962)
oil on canvas 183 × 251.5 (72 × 99)

82
Scent machine no.3 1981 (0968)
oil on canvas 122 × 152.4 (48 × 60)

83
Homage to Homo Australis no.10
1981 (0982)
oil on canvas 213.4 × 172.8 (84 × 68)

84 [pl.25]
Study for an Elizabethan spirit no.9
1982 (01009)
oil on canvas 213.4 × 172.8 (84 × 68)

85
Songs of the grackle no.15 1982
(01012)
oil on canvas 101.6 × 122 (40 × 48)

86 [pl.26]
**Hallucination with monster on red
ground** 1984 (01037)
oil on canvas 122 × 152.4 (48 × 60)
Gimpel Fils

87 [pl.27]
**Meditations on Jain cosmology no.2
(with elephant)** 1984 (01046)
oil on canvas 213.4 × 172.8 (84 × 68)

88
**Meditations on Jain cosmology no.4
(with dog and fox)**
1984 (01048)
oil on canvas 172.8 × 213.4 (68 × 84)

89 [pl.29]
Meditations on Jain cosmology no.6
1985 (01062)
oil on canvas 213.4 × 172.8 (84 × 68)

90
Magic fountain no.9 1986 (01114A)
oil on canvas 152.4 × 122 (60 × 48)

91 [pl.35]
Il mago study no.2 1987 (01117)
oil on canvas 228.6 × 289.5 (90 × 114)

92 [pl.30]
Il mago study no.3 1987 (01118)
oil on canvas 183 × 152.4 (72 × 60)

93 [pl.36]
El poder de locomotion del hombre
1989 (01155)
oil on canvas 122 × 152.4 (48 × 60)

94
Magic dog no.2 1989 (01157A)
oil on canvas 152.4 × 183 (60 × 72)

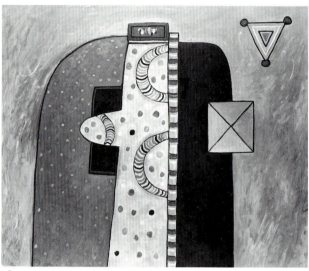

78

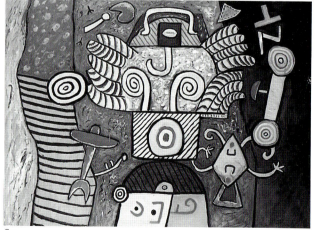

80

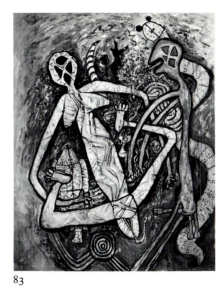

83

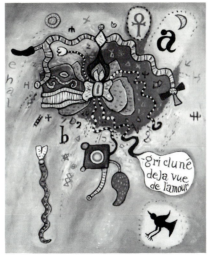

85

90

81

94

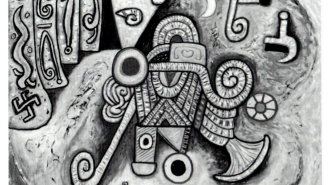

82

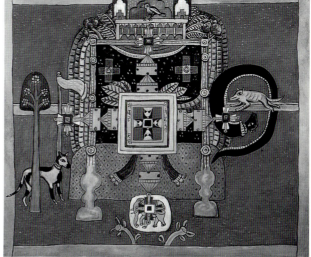

88

95
Un pajaro volando 1989 (01162)
oil on canvas 203 × 172.8 (80 × 68)

96 [pl.39]
Confesionario 1989 (01163)
oil on canvas 172.8 × 203 (68 × 80)

97 [pl.41]
Hopi studies no.30 1991 (01171)
oil on canvas 172.8 × 203 (68 × 80)

98
Hopi studies no.32 1991 (01173)
oil on canvas 203 × 172.8 (80 × 68)

99 [pl.44]
Enchanted village no.1 1992 (01188)
oil on canvas 152.4 × 183 (60 × 72)

100 [pl.45]
Souvenir of Venezuela 1992 (01193)
oil on canvas 183 × 152.4 (72 × 60)

101 [pl.46]
Enchanted village no.4 1992 (01199)
oil on canvas 122 × 152.4 (48 × 60)

102
Homage to an earth goddess no.6 1992
(01208)
oil on canvas 213.4 × 172.8 (84 × 68)

103
Homage to an earth goddess no.8 1992
(01210)
oil on canvas 213.4 × 172.8 (84 × 68)

104 [pl.48]
Homage to an earth goddess no.9 1992
(01211)
oil on canvas 213.4 × 172.8 (84 × 68)

105 [pl.47]
Room of the shaman 1992 (01214)
oil on canvas 172.8 × 213.4 (68 × 84)

GOUACHES

106
Ideas for a children's wall no.2 1969
(G573)
gouache 53.3 × 78.4 (21 × 30)

107
Phantom in the room no.2 1970 (G702)
gouache 55.8 × 78.4 (22 × 30)

108 [pl.14]
Eye of life no.1 1970 (G707)
gouache 55.8 × 76.2 (22 × 29¾)

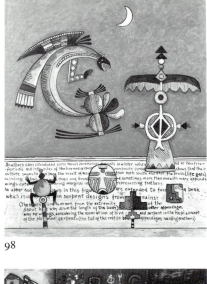

98

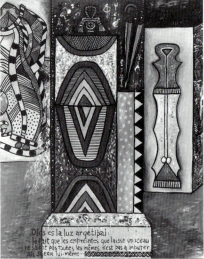

102

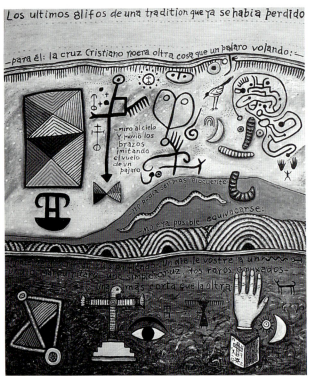

95

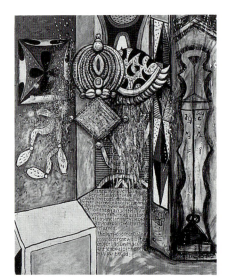

103

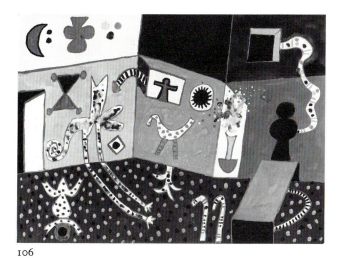

106

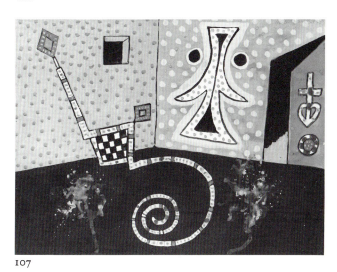

107

109

110

111

109
Spirit room no.3 1972 (G841)
gouache 55.8 × 78.4 (22 × 30)
Gimpel Fils

110
The studio no.6 1974 (G890)
gouache 55.8 × 68.6 (22 × 27)

111
**Hallucination with red-headed
parrot** 1983 (G1854)
gouache 59.7 × 73 ($23\frac{1}{2} × 28\frac{3}{4}$)

113

114

112

112
Meditation with red-breasted bird
1984 (G1861)
gouache 73 × 58.4 (28¾ × 23)

113
Hallucination with gold frog 1984
(G1879)
gouache 59.7 × 73 (23½ × 28¾)

114
Mystic vision, blue bird 1985 (G1912)
gouache 29.2 × 36.8 (11½ × 14½)

115
Creation du monde des Animaux
1988 (G2070)
gouache 73.7 × 59.7 (29 × 23½)

116
**The universe exists only at the point
of balance** 1989 (G2091)
gouache 67 × 56 (26¼ × 22)

117 [pl.34]
Tigrette 1989 (G2099)
gouache 70 × 57 (27½ × 22½)

118 [pl.38]
Crusader 1989 (G2100)
gouache 52 × 42 (20½ × 16½)

119 [pl.37]
Hopi studies no.7 1990 (G2119)
gouache 57 × 69.5 (22½ × 27¼)

120
Hopi studies no.17 1990 (G2129)
gouache 57 × 69.5 (22½ × 27¼)

121
Hopi studies no.27 1990 (G2139)
gouache 28.5 × 38 (11¼ × 15)

BRUSH DRAWINGS

25 works, various dimensions

115

120

121

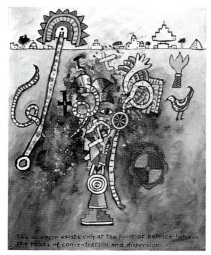

116

1951
HERBERT READ, *Contemporary British Art*,
Penguin Books, London
1956
ANTON EHRENZWEIG, 'The modern artist
and the creative accident', *The Listener*,
London
1958
DAVID LEWIS, 'Alan Davie', *Accent* 1,
Leeds
BRYAN ROBERTSON, 'Alan Davie', *Books
and Art*, London
DAVID LEWIS, catalogue introduction for
Wakefield retrospective
BRYAN ROBERTSON, catalogue introduction
for Whitechapel retrospective
1959
SAM HUNTER, 'European art today', *Art in
America* 3
1960
ALAN BOWNESS, 'Alan Davie', *Aujourd'hui*
26, Paris
ALAN BOWNESS, catalogues for exhibitions
at Gimpel Fils, London, Galerie Charles
Lienhard, Zurich, and Galleria del
Naviglio, Milan
1961
ROBERT MELVILLE, 'Alan Davie', *Motif* 7
W. SANDBERG AND H. L. C. JAFFÉ, *Pioneers of
Modern Art*, McGraw-Hill, London
1962
W. SANDBERG, catalogue introduction for
the RBA/Amsterdam retrospective
DAVID SYLVESTER, 'Alan Davie and the cult
of painting big', *The Sunday Times*,
London
ROBERT HARVEY, 'The true meaning of the
wheel: an interview with Alan Davie',
Granta, Cambridge
1963
MICHAEL HOROVITZ, *Alan Davie*, Methuen,
London
DIETRICH MAHLOW, catalogue introduction
for Baden-Baden retrospective
ALAN BOWNESS, catalogue introduction for
São Paulo Bienal exhibition
1964
ROBERT MELVILLE, 'The unintentionalism
of Alan Davie', *Quadrum* 15, Brussels
1967
ALAN BOWNESS, *Alan Davie*, Lund
Humphries, London
PIERRE CABANNE, 'Alan Davie', *Arts Loisirs*
75, Paris
BARRIE STURT-PENROSE, 'Alan Davie', *The
Observer* colour supplement, 21 May

1979
J. BURR, 'Magic and ritual', *Apollo* 211, 110
1981
J. R. TAYLOR, 'Out on his own', *Art and Artists* 181, October
1985
ROGER BERTHOUD, 'Encounter with Alan Davie', *Illustrated London News*, September
1987
JACQUES ROCHE-VILLIERS, catalogue introduction for Galerie Louis Carré exhibition, Paris
1988-9
DOUGLAS HALL, catalogue introduction for travelling exhibition in Scotland, organised by South West Galleries Association
1989
KEITH PATRICK, 'An interview with Alan Davie', *The Green Book* III, 3
CHARLES BOOTH-CLIBBORN, 'Monotypes', *Print Quarterly* VI, 3
1990
KEITH PATRICK, '70th birthday tribute', *Art Line*, October
WILLIAM CROZIER, 'A beacon in the gloaming', *Art Line*, October
1991
DANIEL WHEELER, *Art Since Mid-century : 1945 to the Present*, Thames and Hudson, London
ANNA MARKOWSKA, catalogue introduction for Gallery 'M', Cracow
IAIN ROY, 'Alan Davie: Scotland's grand master', *Modern Painters* 4, 4
1992
DOUGLAS HALL, 'Introducing Alan Davie', and MICHAEL TUCKER, 'Music man's dream' in *Alan Davie*, Lund Humphries, London
ANDREW PATRIZIO AND JAMES COXSON, 'A handful of sounds : the art of Alan Davie' in *Solo : The Alan Davie Retrospective*, McLellan Galleries, Glasgow
JOHN GRIFFITHS, 'Alan Davie', *Contemporary Art* I, I
DUNCAN MACMILLAN, 'Magic pictures', and BILL HARE AND ANDREW PATRIZIO, 'An interview with Alan Davie' in *Alan Davie : Works on Paper*, Talbot Rice Gallery, Edinburgh/The British Council, London
1993
ANDREW LAMBIRTH, 'In conversation with Alan Davie', *The Artist's and Illustrator's Magazine* issue 76

Contributors

Michael Tucker (*b*.1948) is a Principal Lecturer at the University of Brighton and a reviewer for *Jazz Journal International*, London. Co-author of the recent Lund Humphries monograph *Alan Davie*, he has also published several extensive articles and catalogue essays in the field of Nordic studies. His *Dreaming with Open Eyes : The Shamanic Spirit in Twentieth Century Art and Culture* was published in 1992.

Lynne Green is a freelance art historian and co-editor of the journal *Contemporary Art*. Her publications include *Earthscape* (Hastings Trust, 1991), and *Temenos : Maurice Owen Sculptures* (Southampton Art Gallery, 1990). While at the Hayward Gallery she organised the highly successful *Edward Burra* and *Boyle Family* exhibitions.

Iain Roy is a Principal Lecturer at the University of Brighton where he teaches both the history of art and photography. His first one-man show, *Waiting for the Light*, was shown in 1989 and *Collected Photographs* exhibited in Japan in 1991. He is currently working on another exhibition, *Returning North*, based on a sequence of seven expeditions to Greenland.

Philip Ward, poet, novelist and travel writer, is the author of many poetry collections, including *A House on Fire*, *Imposters and their Imitators*, and *Lost Songs*, and numerous travel books.

Ian McKeever (*b*.1946) is one of Britain's foremost contemporary painters. His show of *Paintings : 1978-1990* was held at the Whitechapel Art Gallery in 1990.

Albert Irvin (*b*.1922) has produced some of the most joyous examples of abstract painting over the past thirty years. His show *Paintings 1960-1989* toured Britain in 1990.

Dr Brian Bates is Senior Lecturer in Psychology and Director, Shaman Research Project at the University of Sussex. He is author of the acclaimed *The Way of Wyrd : Tales of an Anglo-Saxon Sorcerer* and *The Way of the Actor : A New Path to Personal Knowledge and Power*.

Kenneth White (*b*.1936) is Professor of Twentieth-century Poetics at the Sorbonne. He has published a wide variety of award-winning novels, collections of essays and poems.

Barry Guy (*b*.1947) is a virtuoso double-bass player and composer. A founder member of the London Jazz Composers' Orchestra, he has worked with Alan Davie on many occasions.

John Bellany (*b*.1942) is one of Scotland's most important post-war artists. His works are in the collections of the Tate Gallery, the Museum of Modern Art, New York and the Metropolitan Museum, New York.

Frans Widerberg (*b*.1934) is Norway's most important contemporary painter working in the Expressionist tradition. His show *Paintings 1980-92* was part of the Barbican festival *Tender is the North* in 1992.

Jan Garbarek (*b*.1947) is the most distinctive Scandinavian saxophonist and composer of the past three decades. He has recorded numerous award-winning albums for the ECM label.